IMAGES
of America

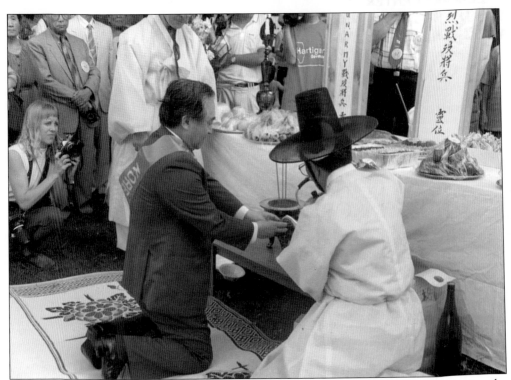

Some traditional customs still remain strong in the Korean American community. During the 1989 Korea Day Festival at the Gompers Park on Pulaski and Foster Avenue, Korean Americans who were separated from their families in North Korea perform ritual services to honor their ancestors and to promote spiritual union with their relatives left behind.

Cover: Some members of the Korean American community are seen in Hanbok, traditional dress, on Wacker Drive in 1982 waiting for the Centennial Parade, celebrating the 100th anniversary of U.S. and Korea diplomatic relations to start.

IMAGES
of America

KOREAN AMERICANS
IN CHICAGO

Kyu Young Park, Ph.D.

ARCADIA

First Printed 2003.
Reprinted 2004.

Published by Arcadia Publishing,
an imprint of Tempus Publishing, Inc.
Charleston SC, Chicago, Portsmouth NH,
San Francisco

Printed in Great Britain.

Library of Congress Catalog Card Number: 2003108862

For all general information contact Arcadia Publishing at:
Telephone 843-853-2070
Fax 843-853-0044
E-Mail sales@arcadiapublishing.com
For customer service and orders:
Toll-Free 1-888-313-2665

Visit us on the internet at http://www.arcadiapublishing.com

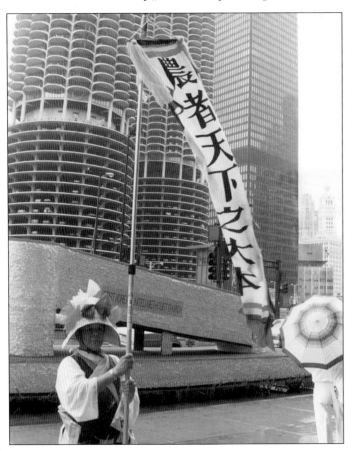

A member of the Korean traditional Farmers' Dance group holds a banner wishing for a bountiful harvest while participating in the 1982 Korean American Parade, celebrating the 100th anniversary of relations between Korea and the United States. Farmers' Dance is a traditional dance that evolved in Korea's agrarian society as a method of easing the hardship of farm labors and of nourishing communal ties within rural villages.

CONTENTS

ACKNOWLEDGMENTS

While I am the principal editor of this book, I received a great deal of assistance from the Centennial Photo Exhibition Planning Committee. Kwang Ja Koo Lee was my co-chair on the committee and the other committee members were: Chang Yoong Lee, K.C. Lee, Chung Sue Yoon, Adrian and Sook Jones, Shin Kim, Aesop Rhim, Joseph Yi, and Rev. Peter Young Kil Kim.

I would especially like to recognize Chong Sik Kim, the former photographer for the *Korean News Service* and the former owner of Lawrence Photo, who has generously donated his time and his photo materials for this book.

In addition, I want to acknowledge the Centennial Committee Chairs, Hyuck Chun and Kyun S. Seok who helped to provide funds to sponsor the photo exhibition upon which this book is based.

I also would like to thank Alice Murata, my colleague at Northeastern Illinois University (NEIU), who gave me the idea and encouragement to edit this book and Mr. Kwang Dong Jo for providing several old and very precious photographs that have been used in this book. NEIU administration and professors also gave me the institutional support to complete this book. I want to also thank President Salme H. Steinberg and Dean Murrell Duster for the encouragement they gave me to complete this work and for the support given to me over the years to develop Korean and Asian Programs at NEIU.

I want to thank my parents, Dr. and Mrs. Tong Hoon Kim, who taught me to love Korean culture and raised me in those traditions. I also want to thank my daughters, Joyce and Eunice Park, for all of the support and encouragement they have provided me for this book.

Finally, I would like to thank Arcadia Publishing, especially Samantha Gleisten, for all of their help in publishing this important book on the Korean-American community in Chicago.

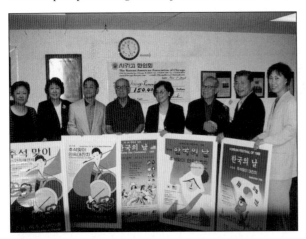

Right: Chung Sik Kim is a former photographer for the *Korean News Service* and the former owner of Lawrence Photo Services.

Left: President Kyun S. Seok (second from right) of the KAAC and the members of the Centennial Photo Committee receive posters designed by Aesop Lim (third from right). (Photograph By Young Sik Cho.)

6

INTRODUCTION

On January 13, 2003, Korean Americans celebrated the centennial of the arrival of 102 non-quota Korean immigrants to work in the sugar and pineapple plantations of Hawaii. This small group has grown to constitute the present population of 1.5 million U.S. citizens of Korean ancestry. This celebration also marks 40 years of immigrant life for an estimated 150,000 Americans of Korean descent who live in the Chicago metropolitan area, most of whom represent the first wave of Korean immigrants under the Immigration Act of 1965, known as the Hart-Celler Act. As late arrivals to this nation, Koreans have come of age in a modern society, proudly presenting a picture of success and travail in this adopted country and city.

This book provides a pictorial history of the cultural contributions that Korean Americans have made to American society in general and to the Chicago area in particular. These pictures commemorate the arrival of the first Korean immigrants to these shores. They are arranged in the book according to various time periods and on the basis of subject matter.

It is hoped that this book will reveal to all Americans living in and visiting the Chicago metropolitan area the importance and magnitude of the contributions made by Korean Americans to the development and growth of Chicago. In addition, this book will expose young Korean Americans to a pictorial history of their forefathers and their achievements in American society, which will help them to develop their own self-identity and self-esteem.

This book is the beginning of what is hoped will be a series of books documenting Korean-American culture, society, and achievement in the Chicago metropolitan area, for it was not possible to capture all aspects of Korean-American life in this book. There were many wonderful photos that could not be included in this book due to the lack of sufficient space. It is hoped that future books and publications will help to further document the breath and depth of Korean-American culture and society in the Chicago metropolitan area.

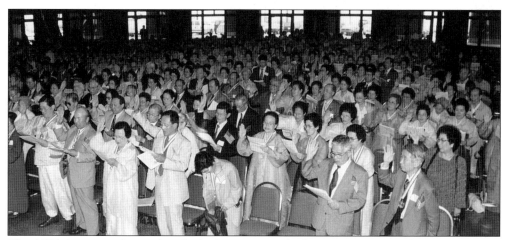

The 1995 American Citizenship Oath Ceremony took place at Navy Pier. This ceremony was notable for the high concentration of elderly Korean Americans taking the oath of citizenship.

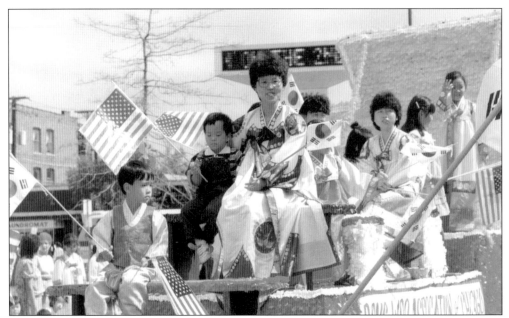

Dong Woo Hoe, the Fellow Workers' Club, participated in a Korea Day Parade in 1985. The Fellow Workers' Club was established in 1973 as a self help organization by Korean-American immigrants who had initially immigrated to Germany as nurses and minors but re-emigrated to the U.S. and were very successful in the Chicago area. The organization is still in existence today, keeping close ties among club members.

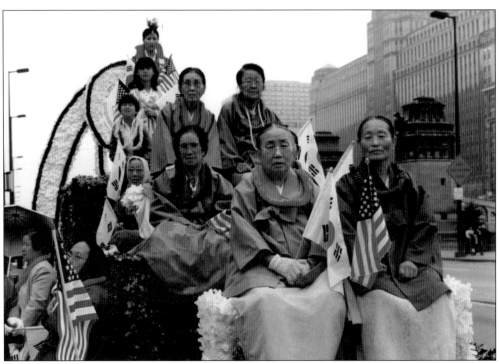

Korean-American Buddhists participate in the 1982 Centennial Parade in downtown Chicago.

One

IMMIGRATION TO THE UNITED STATES

A ship called *The Gaelic* brought 102 Koreans to Hawaii on January 13, 1903 after about three weeks of sea voyage. They were the first Koreans to immigrate as a group to the United States. Many of them were members of Incheon Nae-Rei Church and were persuaded by their pastor, Rev. George Jones, to immigrate. Without his efforts, it is not clear whether that many people could have left Korea since leaving one's native land was regarded as an un-filial thing to do. In any case, there were about 7,000 Koreans who immigrated to Hawaii by 1905. With the Korean government's prohibition on immigration to North America in 1906, the first Korean immigration lasted only three years. Between 1910 and 1924, about 1,000 women immigrated as picture brides. Besides a few students, they were the pioneers of Korean immigration to the United States.

As soon as these Koreans began their lives on Hawaiian sugar plantations, they began to hold worship services and the Korean Methodists Mission was organized officially in 1903. For these Korean immigrants, the Christian church was a natural organization to form because of the fact that close to a half were pre-emigration Christians and active supports of American Christian denominations, especially Methodist. Japan's colonization of Korea in 1910, in fact, made the church the site where the Korean independence movement was safely launched. This tradition of the predominance of Christian churches remains to this day among Korean immigrant communities.

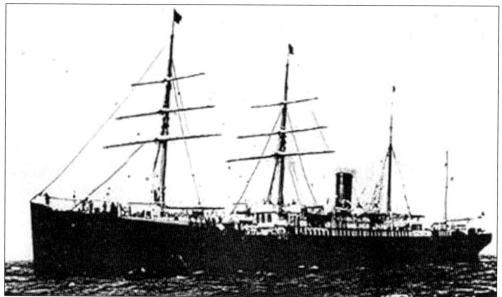

The ship, *The Gaelic*, which brought 102 Korean immigrants to Hawaii, began the first wave of Korean immigration to the U.S. (Courtesy of Rev. Peter Young Kil Kim.)

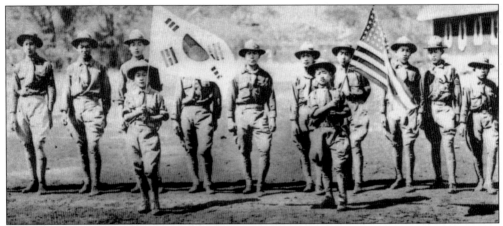

Korean-American Boy Scout troop #19 is pictured here in Honolulu in 1919. (Courtesy of Young Ok Kang and the Korean Centennial Committee.)

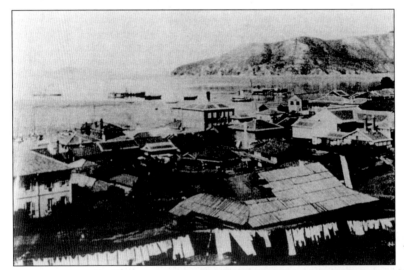

The port of Incheon is pictured here in 1885. The first U.S. missionary, H.G. Appenzella, arrived here on April 5, 1885 with his wife and H.G. Underwood. (Courtesy of Rev. Peter Kil Kim.)

Rev. George Jones of Incheon Nae-Rie Methodist Church encouraged his parishioners to immigrate to Hawaii from Korea. (Courtesy of Rev. Peter Young Kil Kim.)

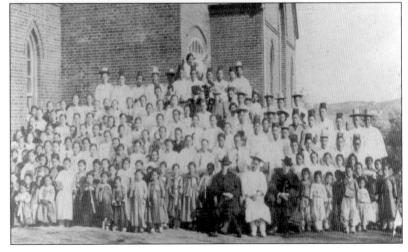

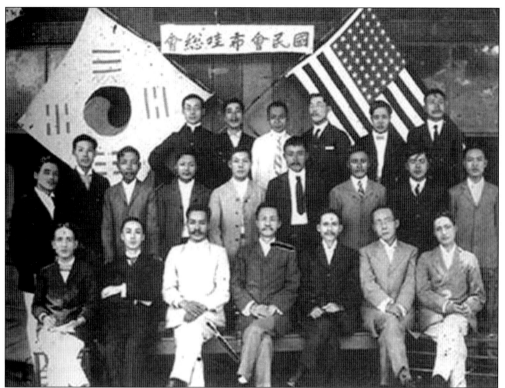

The Korean National Association was established on February 2, 1909 to help promote the independence of Korea and the safety of the Korean people. About 1,000 people took part in this celebration in Honolulu. It was the first Korea Day celebration in United States.

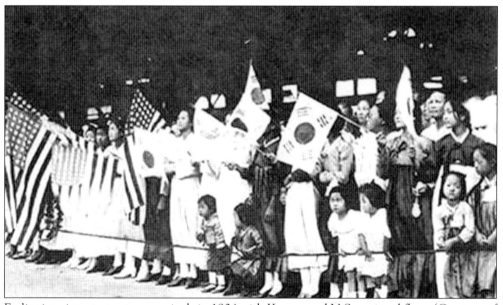

Earlier immigrants greet new arrivals in 1904 with Korean and U.S. national flags. (Courtesy of Rev. Peter Young Kil Kim.)

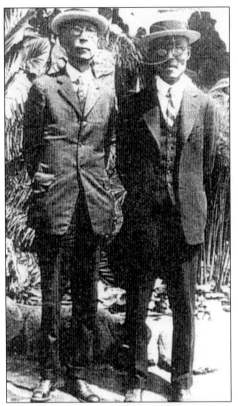

Chang Ho Ahn and So Jai Pil met in Hawaii in 1928. These two prominent historical figures are widely revered in Korea as independence fighters and pioneers. Chang Ho Ahn (right) came to San Francisco in 1902 to study, but he decided to work to improve the living and working environment of Korean immigrants. He formed the Korean National Association (KNA) in 1909. In 1913, he established Hung Sa Dan (Young Korean Academy) as a means of implementing his educational philosophy. So Jai Pil, Dr. Philip Jaisohn (left), came to America in 1885, and in 1890 he became the first Korean to become a naturalized American citizen and also the first Korean to complete his medical training in the United States in 1892.

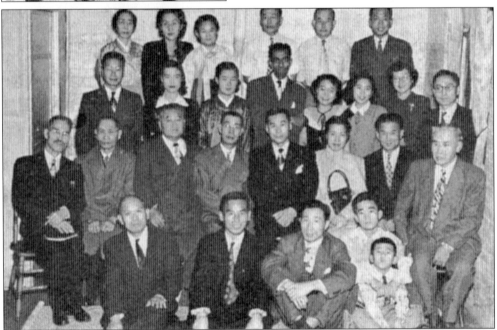

Jason Lee (in the second row, third from left) posed with Rev. Eun Taik Yi (first from left, front row) and First Korean United Methodist Church members in 1948. He operated a Las Vegas-type gambling casino in downtown Chicago. (Courtesy of Kwang Dong Jo.)

Right: This photo shows a young couple who were married through the picture bride program. Between 1910 and 1924, the picture bride program attracted 970 young women to immigrate to Hawaii. (Courtesy of Rev. Peter Young Kil Kim.)

Below: Syngman Rhee, who later became the first president of the Republic of Korea in 1948, founded the Korean Christian Academy in 1918 in Hawaii. Syngman Rhee believed in diplomacy and education to achieve the goal of Korea's independence. He had been imprisoned from 1894 to 1904 for his political activities in Korea. Upon his arrival in the U.S. he began to pursue his goals. He received his Master's degree from Harvard and in 1910, with his degree in International Relations from Princeton, he became the first Korean immigrant to attain a Ph.D. from an American university. (Courtesy of Centennial Committee of Korean Immigration to the United States.)

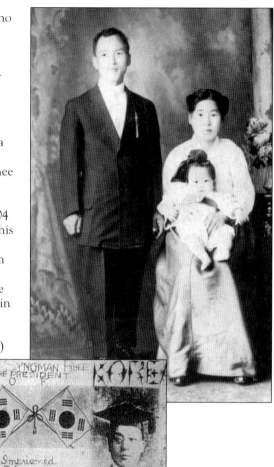

이승만 박사 (1958)
Dr. Syngman Rhee
— Mr. George C. Oh Collection

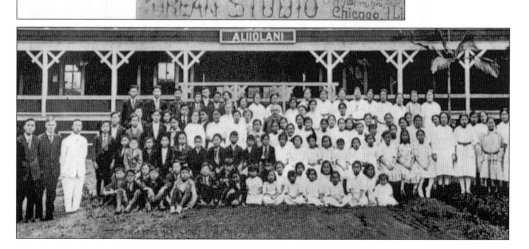

13

Samuel Sa Kyum Bhang is shown as a student at the University of Chicago in 1906 with his wife, Salrome Bhang, who came to the U.S. as a picture bride. (Courtesy of Kwang Dong Jo.)

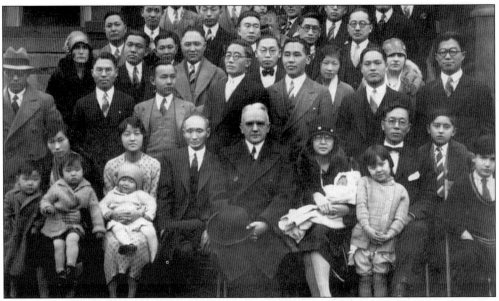

Korean students in the 1920s often gathered at FKUMC every Sunday. At that time there were approximately 30 students from Korea in the Chicago metropolitan area. The picture was taken at their church, 3901 N. Lake Park Avenue, on January 28, 1928. (Courtesy of FKUMC.)

Two

IMMIGRATION TO THE CHICAGO AREA

For the first time in U.S. history, the 1920 U.S. Census recorded about 30 Koreans living in the Chicago area. Most of these people were either Hawaiian immigrants or international students from Korea.

Who was the first Korean to settle in Chicago? There are two different theories. According to one theory, it was Mr. Sah-kyum Pang who was believed to have studied at Wheaton College in 1907. On the other hand, some believe it was Mr. Kyung Kim who settled in 1912.

The first ethnic Korean church—First Korean United Methodist Church in Chicago (FKUMC)—was organized by 1923. As in Hawaii, this church became the sole center of activities among Koreans, whether Christians or not, until 1964. Thus, the history of the early Chicago Korean community is synonymous with this church's history. Even though this church went through lots of travails, it nonetheless was able to remain open through Rev. Eun Taik Yi's almost single-handed efforts.

More Korean immigrants to Hawaii moved to Chicago, and by 1930, the U.S. Census documented 76 Koreans in the Chicago area. Before the end of World War II in 1945, there were some later well-known Koreans studying in colleges and universities around Chicago. Until the Korean War, however, the number of Koreans in the Chicago area only increased naturally.

Students started to arrive around 1948; larger groups of students started to come after the Korean War. During this period of growth, there were many activities related to starting organizations; notable among them were the Korean Student Association and the Korean Medical Association.

After the Korean War, the number of Korean children adopted by American families and Korean women married to American soldiers increased. A great majority of them were not connected to the Korean community. As more students from Korea arrived in the Chicago area and with the 1965 revision of U.S. immigration laws, the Korean community experienced an explosive growth after 1965.

The church was the only Korean organization in Chicago during this period. It was more than a place of worship—it was the gathering place for all Korean activities. It was above all a little bit of "home." This dual role the church plays, namely as a place of worship and socializing, contributed to the phenomenal growth of the number of churches in later years.

This photo shows a dinner party for students in the Midwest in 1933.

This 1927 picture shows some members of the First Korean United Methodist Church (FKUMC). The first Chicago Korean church, the First Korean United Methodist Church, was organized in 1923. It moved from its original location on the North Side (Lincoln Avenue), to the South Side (Lake Park Avenue), and then finally settled down on the North Side at 826 W. Oakdale Avenue where it remained until 1963. (Courtesy of Chang Yoong Lee.)

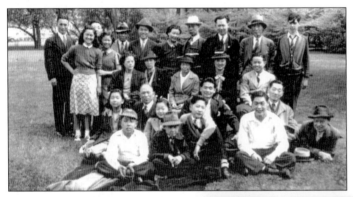

Left: Pictured here is a church picnic in 1940. (Courtesy of Chang Yoong Lee.)

Right: In 1936, the First Korean United Methodist Church members gathered in front of their new church with Rev. Eun Taik Yi (first person, fourth row from right) who was the pastor of FKUMC from 1936–1964 at 826 W. Oakdale. Garrett Evangelical Theological Seminary established an endowment fund named in their honor in 2001. (Courtesy of Joseph Yi.)

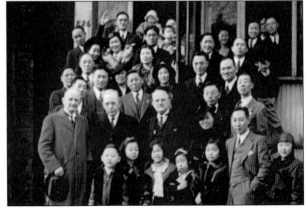

16

Kyung Kim is believed to be the first Korean to settle in the metropolitan Chicago area in 1915. According to Mr. Kwang Dong Jo, former editor of Chicago's *Korea Times* and now vice president of Korean-American Television, Kyung Kim came to the United States in 1906 as a student of architecture who started out by designing small houses here and later made his fortune as the owner of various Chicago cafeterias. At one point he owned five restaurants. His biggest restaurant was the Washington Cafeteria at State and Randolph Streets. He gave financial help to important historical figures such as Syngman Rhee, who later became president of the Republic of Korea, and early independence fighters such as Ahn Chang Ho and So Chae-p'il. (Courtesy of Kwang Dong Jo.)

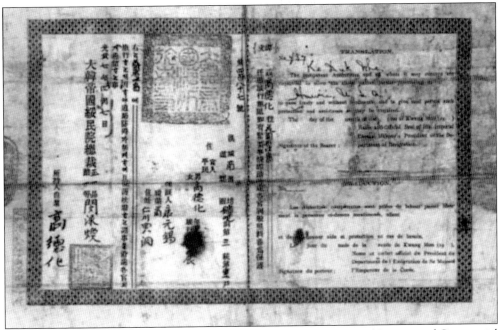

This Imperial Korean Passport was issued to Duk Wha Ko in 1903. (Courtesy of Centennial Committee of Korean Immigration to the United States.)

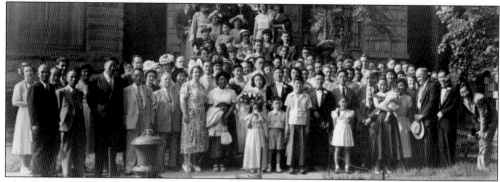

This is the wedding picture of Sunda Yi, the eldest daughter of Reverend Yi, in 1949. This was the first social gathering of Korean young adults after Korean Independence. The first person in the front row on the left is Reverend Yi and the third tallest man in the double breasted dark suit is Mr. Hang Sup Chun who was a member of a goodwill mission to the U.S. from Korea, which was sent by Republic of Korea President Syngman Rhee. (Courtesy of Chang Yoong Lee.)

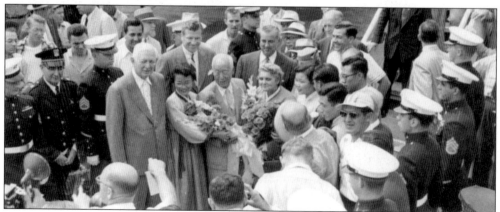

Syngman Rhee and his wife (first two people from the left, second row) met with Korean community members in 1954. (Courtesy of Chang Yoong Lee.)

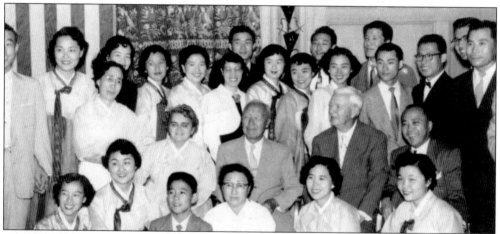

Syngman Rhee, the first president of Korea, visits Chicago in August 1954. This image shows President Rhee's news conference at O'Hare Airport. (Courtesy of Chang Yoong Lee.)

This is the wedding photo of Mr. and Mrs. K.C. Lee. K.C. Lee's marriage ceremony took place in December 1954 at FKUMC on Oakdale Street in Chicago. K.C. Lee came to America in 1948 on a non-immigrant student visa. He was the first Korean-American pharmacist in the Chicago area. He remains active in the Chicago community and was a former president of the Pharmacists Association of Chicago. (Courtesy of K.C. Lee.)

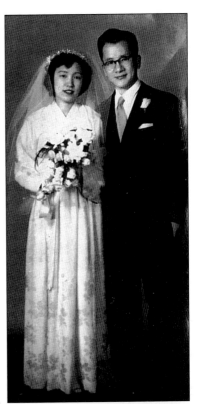

On January 16, 1966, the *Chicago Tribune Magazine*, in its Sunday issue, featured Chicago's Koreans in an impressionistic profile authored by K.C. Lee. (Courtesy of K.C. Lee.)

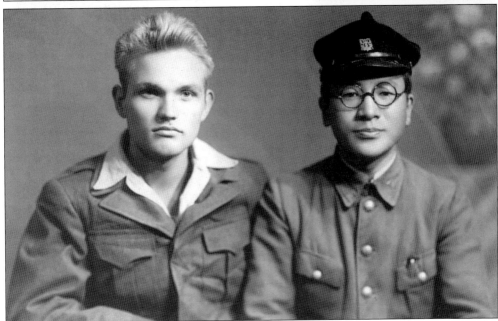

K.C. Lee is seen here as a student at the Seoul Pharmacy College, the only pharmacy school in Korea, then under Japanese occupation. During the U.S. Government's control over Korea after World War II, K.C. Lee took the opportunity to practice his English by fraternizing with "GI" friends. Shown also is "Ruby" a native of Des Moines, Iowa. (Courtesy of K.C. Lee.)

19

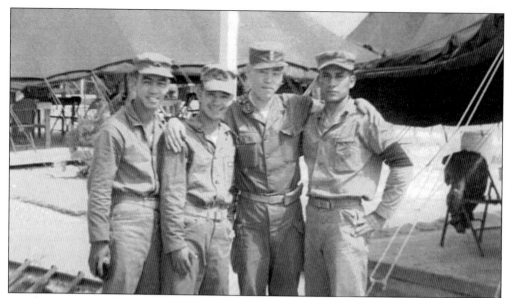

Joseph Yi was the only Korean American in the U.S. Marine Corps during the Korean War. He served in combat and was the head interpreter and translator when POWs were repatriated after the end of the war. As a son of pioneer minister Rev. Eun Taik Yi, he actively participated in providing voluntary social services for the Korean-American community. (Courtesy of Joseph Yi.)

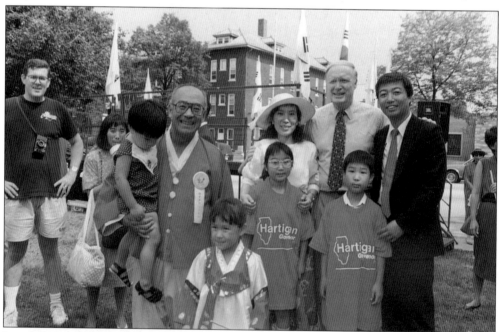

Joseph Yi (center, in traditional Korean outfit) his grandchildren, his daughter, and her husband, pose with gubernatorial candidate Neil Hartigan and Sang-Gu Cha's family at the 1986 Korea Day Festival. Joseph Yi came to America in 1940, at the age of ten, and has basically lived in the Chicago metropolitan area since. After his return to Chicago from the war, he went on to work for the Illinois State Department of Transportation and then the Pollution Control Board for many years until he retired in 1999. (Photograph by Chong Sik Kim.)

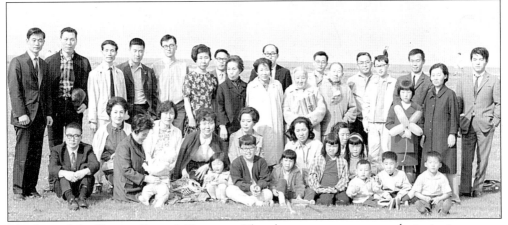

Members of the Korean Central Covenant Church are seen at an annual picnic, in a group photo taken in June 1968, at a Lake Michigan Beach. Pictured, second row, second person from the right, is Sung Ok Hong Kim, and the fifth person from the right in the back row is her husband Tae Bum Kim. (Courtesy of the *Korean Times Chicago*.)

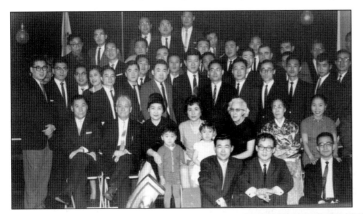

Left: At this gathering of Korean Students Association of Chicago area in 1962, the president of the association, Paul Chung is visible in the second row; he is the first person sitting.

Right: This Kim family photo was taken in 1967. Tae Bum Kim and his wife Sung Ok Hong Kim met at Aurora College and got married in 1954. Tae Bum Kim received his Master's degree in International Relations from the University of Chicago in 1955. His wife was one of the assistant-superintendents of the Chicago Public Schools. She was the highest-ranking Asian in the Chicago Public School System and was very active in the Korean-American community serving as the first president of the Korean Women's Association, vice president of the Korean-American Association of Chicago, and once was the chairperson of the Korean American Community Services Board. (Courtesy of the *Korean Times Chicago*.)

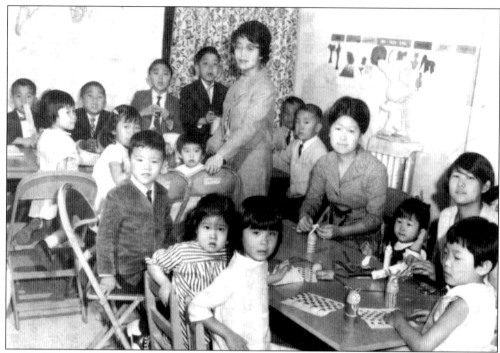

A Sunday school class of FKUMC is seen here in this photo from 1964. In the late 1960s, Korean-American Sunday schools were formed to teach Korean culture and language in the Chicago area. It is believed that the first Korean school was the Chicago Korean School, which was established by the eighth president of the Korean American Association of Chicago, Paul Park and the secretary general of the YMCA, Rev. Young Hee Park. The first classes were held in the YMCA building on Lincoln and Barry Street in 1971. Sook Ja Kim was one of the first Korean language teachers in the Chicago metropolitan area. (Courtesy of Chang Yong Lee.)

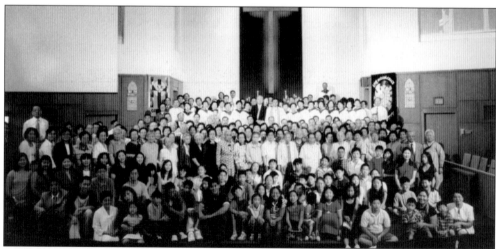

FKUMC is seen here at N. Bernard Street where the church moved in 1981 from the old church building at 22 W. Erie Street. The church sold the building in 2002 and moved to a northern suburb. Here, in 2002, church members of FKUMC are at their last worship service on Bernard Street. (Courtesy of Chang Yong Lee.)

Three
COMMUNITY
1965–2002

The Hart-Celler Act of 1965 abolished the National Origin Quota System for immigration to the United States. This permitted a large number of Koreans to immigrate to the U.S., especially to large cities. Thus, Korean immigrants started to arrive in Chicago in greater numbers. This situation also helped to form new organizations to advocate for the Korean-American community. These organizations included the establishment of the Korean-American Association of Chicago and the Korean-American Community Services.

The largest Korean church in the Chicago area, First Korean United Methodist Church, split in 1965, and various denominations began to spread and organize themselves into new churches. By about 1980, the total number of Korean churches in Chicago—of all denominations—had grown to about 150.

The first daily Korean newspaper, the *Korea Times Chicago*, was established in 1971. Koreans also became well represented in academia in the U.S. as well as in medicine. Medical professionals in a variety of fields began to make their way to the U.S. from Korea in great numbers during the 1960s and 1970s. A group of nurses, for example, immigrated to Chicago from West Germany beginning in 1968. They had gone to West Germany as "guest workers" in the 1960s, as did a group of young men employed as miners. After arriving in Chicago, the nurses organized the Midwest Korean Nurses Association and the miners set up the Fellow Workers' Club in 1969. This type of professional association was a very common aspect of the Korean community in the U.S. as immigrants joined together to overcome common problems and share their combined experiences.

Beginning with the establishment of Korean-American Community Services in 1972, the number of social service providers in the Chicago area has grown rapidly. By 2003, there were more than 30 social and volunteer service organizations, providing a variety of community services including: child care, youth programs, adult day care and other elderly services, anti-domestic violence, counseling, adopted children services, hungry children programs, and other services.

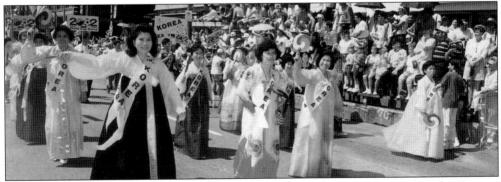

This August 1994 parade scene down Chicago's Michigan Avenue was staged by the Korean-American Women's Choir group. Here they are jubilant over the just announced 2002 World Cup soccer event due to be hosted by the Republic of Korea in co-sponsorship with Japan. (Courtesy of Kwang Ja Koo Lee.)

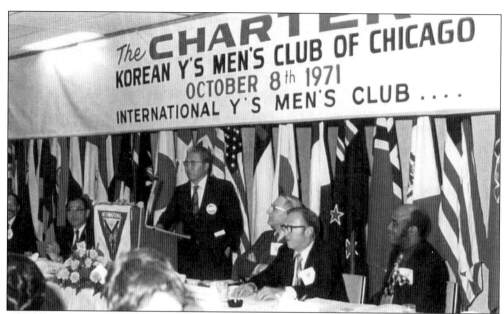

The inauguration of the president of the Y's Men's Club of Chicago by Dr. Won Tae Son, who was the first chairperson of the board of directors of the Korean-American Association of Chicago (KAAC), is seen here. (Courtesy of KAAC.)

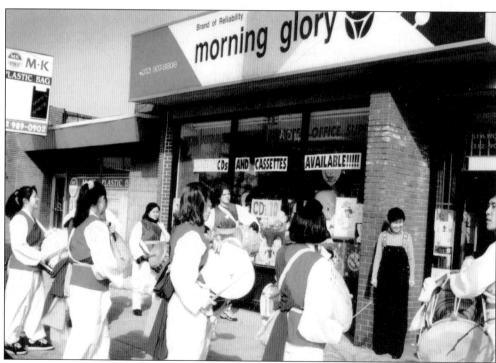

This "Stepping on the Spirit of the Earth Ceremony" is being held at the Morning Glory stationary store on Lawrence Avenue. This ceremony is a part of the Korean Lunar New Year's celebration and annually this event is performed by the Work and Play group. (Courtesy of Korean-American Resource and Cultural Center.)

The Comprehensive Korean Self Help Community Center (Mutual Assistance Society) was established on Pulaski Road in Chicago to help new immigrants and the needy in the Korean-American community in 1985. (Courtesy of Self Help Community Center.)

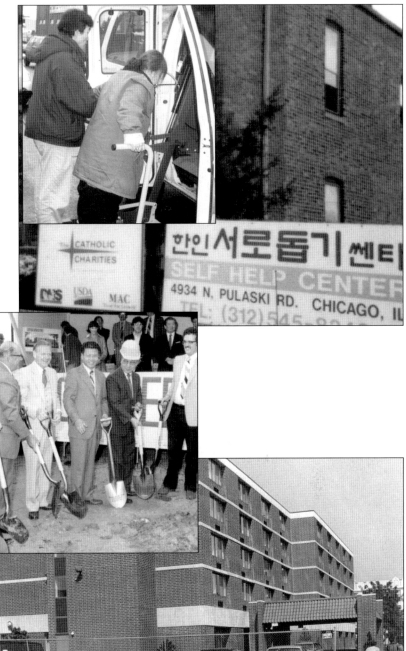

These pictures show the ground-breaking ceremony for the construction of the Moo Goong Terrace, a senior citizen housing complex in 1983 and the building after the completion of construction. This senior apartment complex is being managed by Korean-American Community Services and will go down in the annals of the Korean community of Chicago as the epitome of Korean-style compassion for fellow countrymen. (Photograph by Chong Sik Kim.)

Above: This photo show the Cross-Cultural Holiday Choral Festival Communion of African Americans and Korean Americans.

Left: Two children from each community teach each other dance steps.

Below: Korean-American and African-American students learn each others' traditional dances at a cultural exchange program in 1994. (Courtesy of Korean-American Chamber of Commerce.)

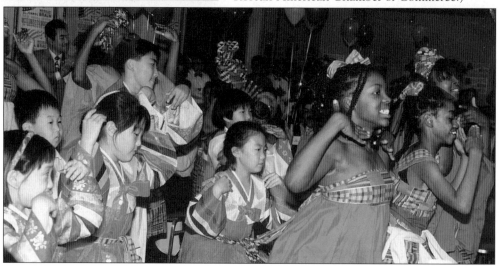

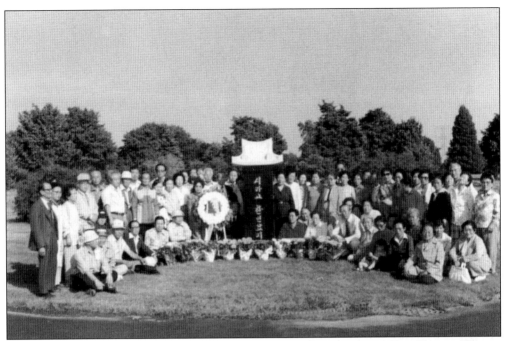

This is a Korean-American cemetery site at Ridgewood Cemetery in Des Plaines, Illinois. (Courtesy of Rev. Peter Young Kil Kim.)

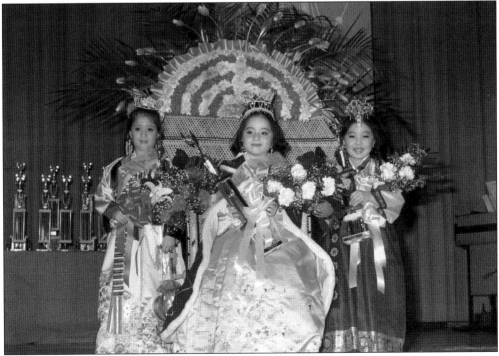

A Little Miss Beauty Pageant has been held annually in the Korean-American community since 1980. Here are the winners for the Little Miss Pageant of 1985. (Photograph by Lawrence Photo; Courtesy of Chong Sik Kim.)

Dr. and Mrs. Paul Borah Chung, a prominent dentist and professor at the Northwestern University School of Dentistry, along with Linda Yu (news anchor, ABC) are pictured at the first Asian-American Coalition Lunar New Year Celebration in 1984. Dr. Paul Chung was the first Korean graduate of an American dental school. He graduated from Northwestern University, School of Dentistry in 1938. He was the first honorary consul for Chicago and the Midwest before the consulate general of the Republic of Korea was established in 1968. He also served as the first president of the Korean Association of Chicago from 1963 to 1964. (Photograph by Chong Sik Kim.)

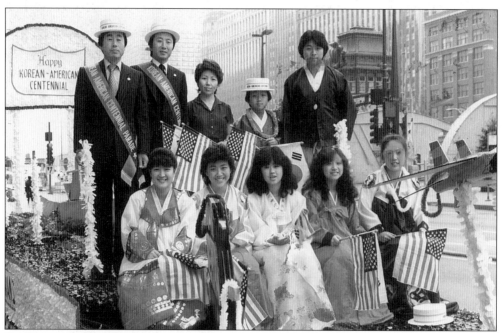

Yung Hwan Kim, vice president of the Korean-American Broadcasting Co., with his family and Kybong Lee, an active board member of KAAC's family, are shown in 1982 on the Korean Martyr's Catholic's float, celebrating the 100th anniversary of the formal treaty between Korea and United States. (Courtesy of Kibong Lee.)

28

Six Korean-American founders of Mayfair Bank are sitting with their guests at the bank's opening ceremony in February 1987. This was the first Korean-American bank to open on Devon Avenue in the Chicago metropolitan area. It subsequently closed in June 1992. (Photograph by Byung Hoon Park.)

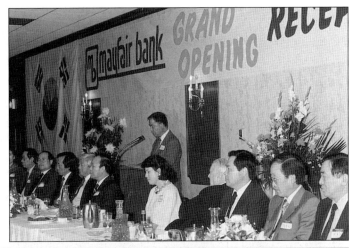

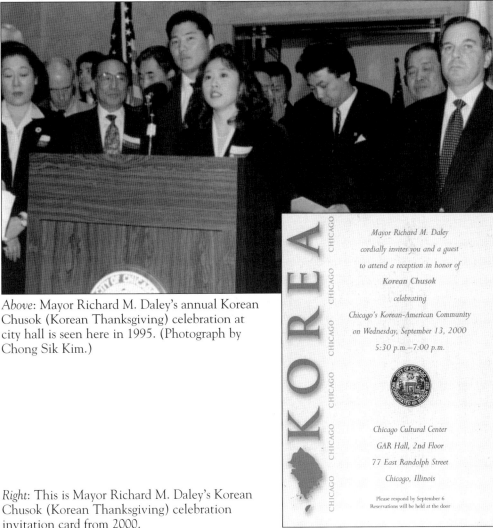

Above: Mayor Richard M. Daley's annual Korean Chusok (Korean Thanksgiving) celebration at city hall is seen here in 1995. (Photograph by Chong Sik Kim.)

Mayor Richard M. Daley
cordially invites you and a guest
to attend a reception in honor of
Korean Chusok
celebrating
Chicago's Korean-American Community
on Wednesday, September 13, 2000
5:30 p.m.–7:00 p.m.

Chicago Cultural Center
GAR Hall, 2nd Floor
77 East Randolph Street
Chicago, Illinois

Please respond by September 6
Reservations will be held at the door

Right: This is Mayor Richard M. Daley's Korean Chusok (Korean Thanksgiving) celebration invitation card from 2000.

Some members of the Korean-American Community Services (KACS) pose in front of its building on California Avenue. KACS was founded in 1972. (Courtesy of Kwang Ja Koo Lee.)

Participants in the Third annual Korea Day Picnic wait in line to purchase tickets for the drawing of gifts.

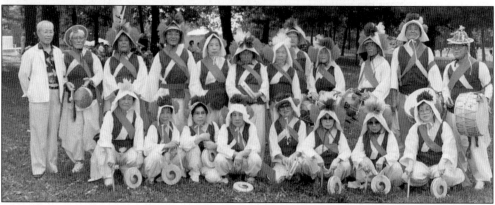

The KASAC Farmers' Dance Team posed before its performance for the Korean Chusok program in 1987. (Courtesy of KASAC.)

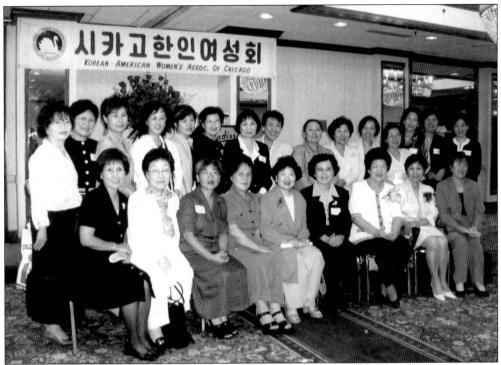

The Korean-American Women's Association of Chicago (KAWA) was founded in 1980. KAWA works actively for the Korean-American community, providing a Women's Corner Radio program and Talk Line for counseling, book club services, and the annual KAWA Choir concert. (Courtesy of Kwang Ja Koo Lee.)

KAWA Choir members pose with Mayor Daley in 1990. (Courtesy of Kwang Ja Koo Lee.)

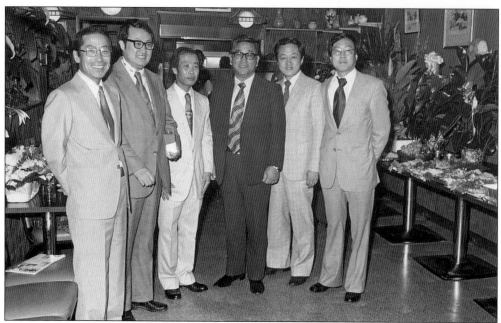

The first Chicago branch office chief of the Korea Exchange Bank, In Kee Ju (third person from right) is shown with Korean-American community members at his welcoming party. The Chicago branch first opened in 1975 on Dearborn Street in downtown Chicago. (Courtesy of Kyung Sik Kwack.)

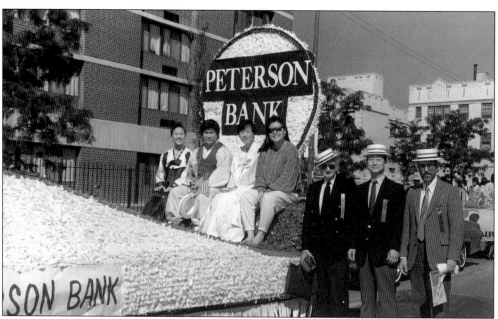

Officers of the Peterson Bank participated in the Korea Day parade to celebrate the 100th anniversary of the formal treaty between Korea and the United States in 1992. This bank later changed its name to MB Financial Bank. Mark Rubert (president) and Charles K. Oh (senior vice president, Korean Department) of the Peterson Bank are shown in the photo. (Courtesy of Chong Sik Kim.)

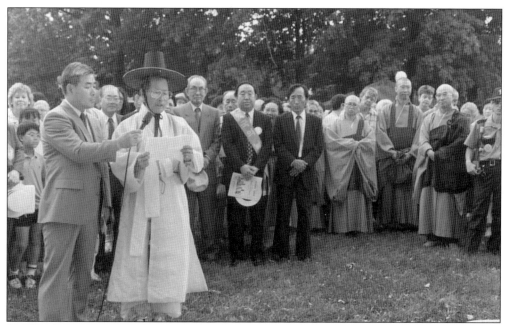

On October 22, 1989, at the Korea Day Festival, Kwang Chul Kim, president of the Hwanghae Province Fellowship Association, is offering Chusok (Korean Thanksgiving) sacrifices to the memory of his great forefathers by holding a solemn ceremony—reading a memorial address, burning incense, and offering fresh food and drink made from the new grains for their old hometowns. (Courtesy of Chong Sik Kim.)

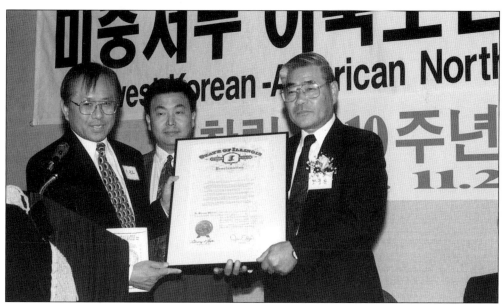

On November 2, 1996, Dr. Yoon Mo Lee (first person from the left), chief of research at the Department of Human Rights of the State of Illinois, presents the proclamation from Governor Jim Edgar to the president of the Northerners' Association, Young Hwan Cho, declaring November 2 as the Midwest Korean-American Northerners' Day in the State of Illinois. (Courtesy of Young Hwan Cho.)

Members of the Korean-American community enjoy social dancing at KAAC's end of the year party in 1989. (Courtesy of Chong Sik Kim.)

Here, the Korean YMCA of Chicago holds an open forum on "The L.A. Riot and the Korean-American Community." (Courtesy of Kwang Ja Koo Lee.)

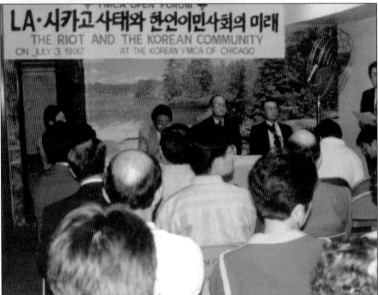

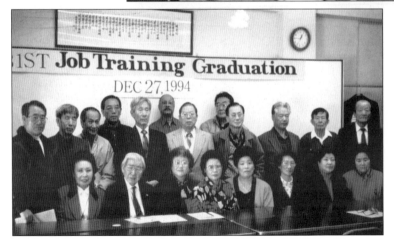

The Korean-American Senior Center "Job Training Program" is pictured in 1994. (Courtesy of Kwang Ja Koo Lee.)

Here, the Center for Seniors' Adult Day Care is having its July 4th Picnic through the Korean-American Senior Center's "Golden Diners Program." (Courtesy of the Center for Seniors.)

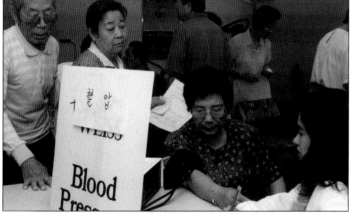

Korean-American Senior Center (KASC) holds an annual medical examination day to provide medical services for senior citizens in 1999. (Courtesy of KASC.)

Participating members of the Korean-American Seniors Association of Chicago's (KASAC) fall group sighting program are waiting for the bus to come in front of the Central Pharmacy on Lawrence Avenue in October 1990. (Courtesy of KASAC.)

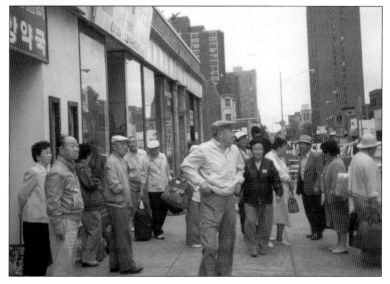

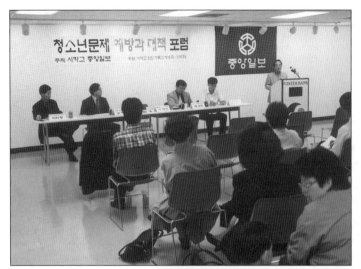

Several community leaders were invited by the Korean Parents Association to hold a forum at Foster Bank Community Center concerning the growing problems of youth groups and the ways to prevent these problems. Detective Sgt. Peter J. Hwang of the Asian Organized Crime Task Force and Chicago Northern Suburban Police Department was one of the speakers. (Courtesy of the *Korea Daily*.)

The Global Children's Foundation, founded in 1998, is a group of Korean-American mothers who help hungry and lost children in countries throughout the world find food and shelter. (Courtesy of Chung Yeol Shim.)

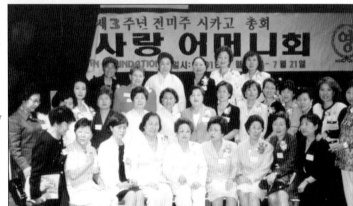

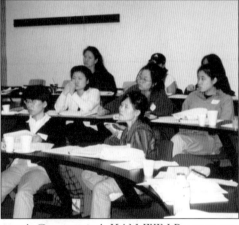

Development of Chicago's Korean-American Women's Community's KAN-WIN Program was organized to address the concern of battered Korean-American women in May 1989. KAN-WIN began its operations with 23 volunteers and a 7 member working board, with a budget of about $10,000. Its services included crisis counseling, referral for shelters, translations, accompaniment to courts, hospitals, and various social services. (Courtesy of Eun Hae Choi.)

The Good Neighbor Program, sponsored by the Korean-American YWCA, is shown in 1991.

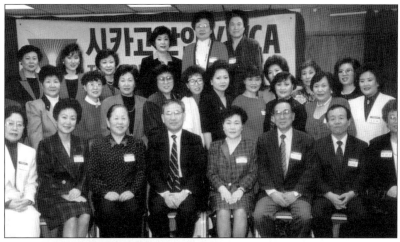

As a part of the Korean-American Association of Chicago's (KAAC) community outreach service, they hosted an annual Christmas party for recent immigrants and their families in 2002. Officers of the Korean-American YWCA also volunteered their time and brought refreshments to introduce the children to an American-style Christmas. (Courtesy of Young Sik Cho.)

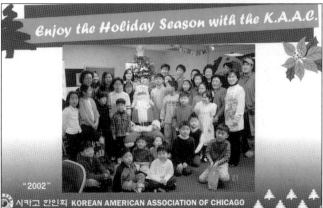

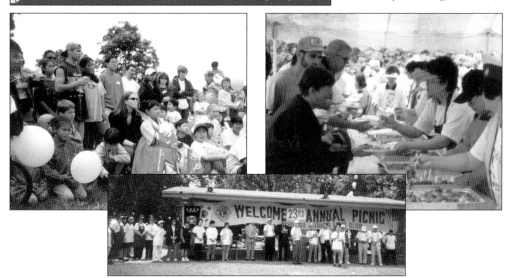

Chicago Arirang Lion's Club held its 23rd annual picnic for the families of Korean adoptees at Blue Star Park in Glenview, Illinois in June 1997. About 300 people enjoyed Korean food and performances of traditional music, dance, and games. (Courtesy of Chicago Lion's Club.)

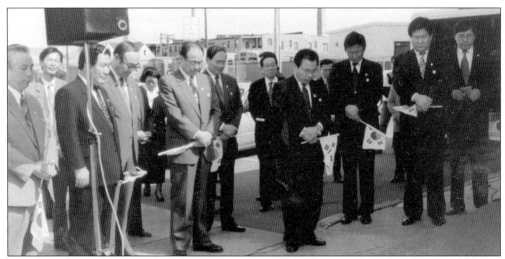

The Seoul Drive installation ceremony at the center of Seoul Drive between Kimball and Kedzie was held on May 19, 1993. Ten Seoul council members from the Republic of Korea, including the chairman of the city council, came to Chicago to celebrate this historical day. They had a moment of silence before the official ceremony. (Courtesy of Chong Sik Kim.)

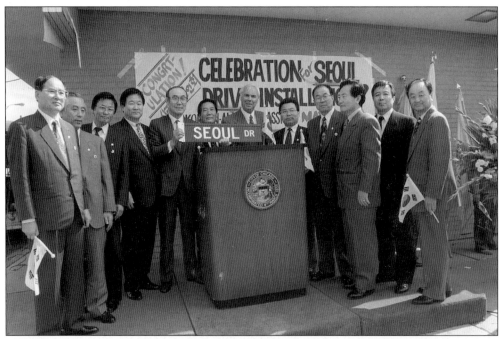

Lawrence Avenue was in a decline as is true of many of the city's old-era shopping areas. There were boarded-up windows and vandalized storefronts, indicating a shopkeeper's demise. Today, the storefronts are bright, colorful, and the stores are thriving. It is no small wonder that such a city beautification program for Lawrence Avenue has caught the eyes of city officials, who have named the thoroughfare Seoul Drive, making it the crown jewel of the Korean-American community of Chicago. The 20th president of KAAC, Hae Rim Chung, and 38th district alderman, Richard F. Mells present a sign designating Lawrence Avenue "Seoul Drive" to the Korean-American community in 1993. (Courtesy of Chong Sik Kim.)

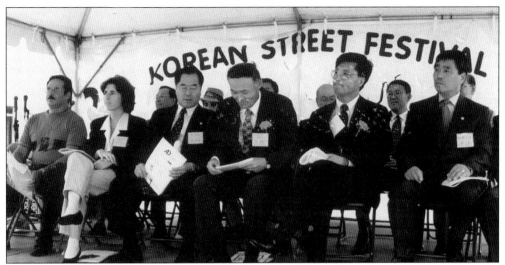

The 39th ward alderwoman, Margaret Laurino sits with Joon Young Kang, chairman of the board of the Korean Consul General of Chicago; Jong Kyu Byun; Peter Lee, president of the KAAC; and Yong Choi, president of the Chicago Korean-American Chamber of Commerce (from left to right) at the third annual Korean Bryn Mawr Street Festival opening ceremony in August 1998. (Courtesy of KACC.)

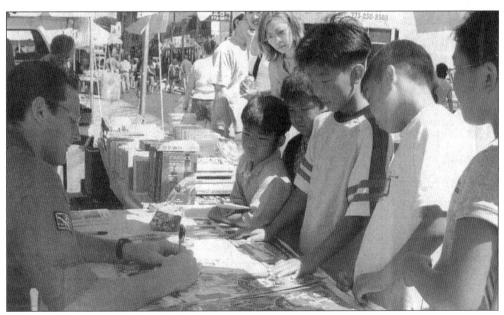

Henry Ring, goal keeper for the Chicago Fire, signs his autograph for this Korean-American youth group at the 2002 Korean Street Festival. (Courtesy of the *Korea Times Chicago*.)

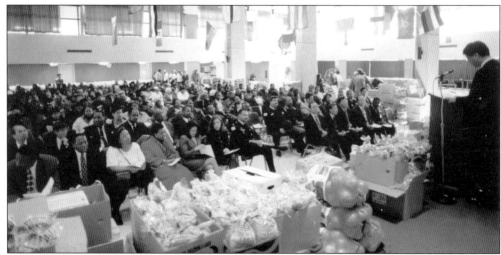

The Korean-American and African-American Friendship Event known as "Christmas Food Basket Program" is seen here. Because many of Chicago's Korean immigrants started businesses in poor, largely African-American neighborhoods, relations between the two communities sometimes have been tense. The Korean-American Merchants Association of Chicago (KAMAC) tries to resolve conflicts between Korean merchants and African Americans through aid and cultural awareness programs. KAMAC presented its 12th Annual Food Basket program at Kennedy King College in December 2001 by distributing 1,500 baskets to needy families. (Courtesy of KAMAC.)

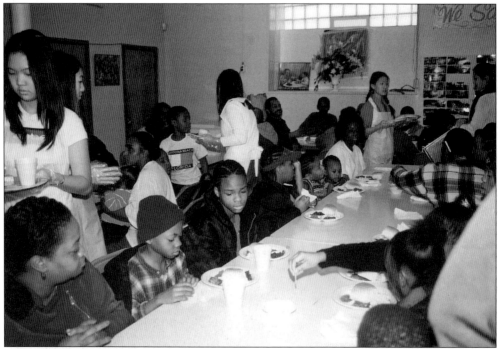

Churches also try to promote friendship between the two communities. Here, Korean-American Church Youth Group members serve lunch to African-American church youth group members as a part of their Soup Kitchen Program. (Courtesy of Canaan Presbyterian Church.)

Chong Sik Kim, his wife Hien Kim, and their youngest son, Thomas Kim are shown in this photo presenting a photo of the late mayor of Chicago, Harold Washington, which he donated to the Harold Washington Library. Senator Paul Simon, who is also shown in the photo with the mayor, is congratulating Mr. Kim on this occasion. The photo will be displayed permanently at the library. Mr.Kim and his Vietnamese wife, Hien, fled Saigon carrying only their one year-old son, Nam, a camera, and photos. He was a former photographer for a Korean news service and was working at the Korean Embassy in Saigon covering the war. They were among the last people to escape Saigon. (Courtesy of Chong Sik Kim.)

Sgt. John Lee and his parents pose with Terry G. Hillard, superintendent of police for Chicago at the Korean-American community forum in 2002. (Courtesy of Chang Yoong Lee.)

41

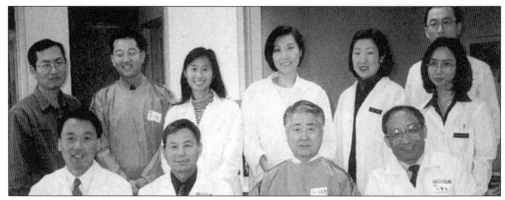

The Korean-American community's 21st annual Korean-American Health Fair was held at Swedish Covenant Hospital on October 10, 1988. Pictured, from left to right are: (seated) Joward Jeon, Jin Moon Soh, Sung Hwan Suh, Chul Joo Lee; (standing) Chungyoon Ha, Joseph Hwang, Nayonge Soh, Hanna Kim, Minna Chung, Gloria Chun, and Joohwan Kwon. (Courtesy of KADA.)

The Korean ROTC Association of the Midwest was established in 1982. A group of its members pose at their annual meeting to greet the new members in 2002. (Courtesy of Korean ROTC Association.)

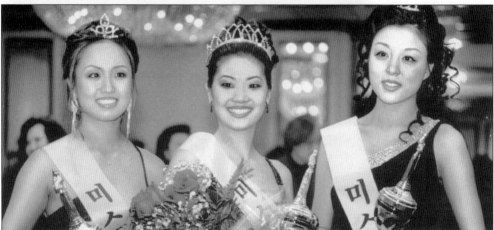

The annual Miss Korea Pageant held in 1992 took place at the Radisson Hotel in Lincolnwood; the event sends a pageant contestant as an overseas representative from Chicago's Korean-American community. Angie Cho (in the center), who attended Duke University and majored in Biology, won the title. Other contestants included on her right, Ms. Sung Ah Min, the first runner up; and on her left, Sujin Lim, second runner up. (Courtesy of the *Korea Times Chicago*.)

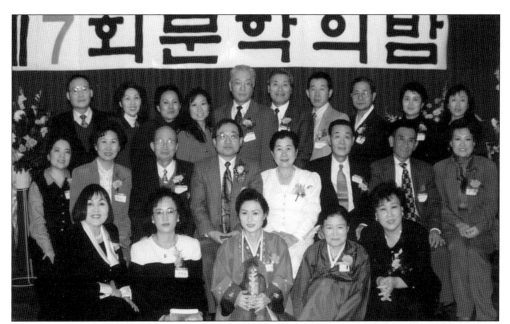

Chicago Korean Literary Society (CKLS) members are seen here after attending the seventh annual Literary Conference held in September 1996 at the Foster Community Center. This literary society was first formed in September 1984. (Courtesy of CKLS.)

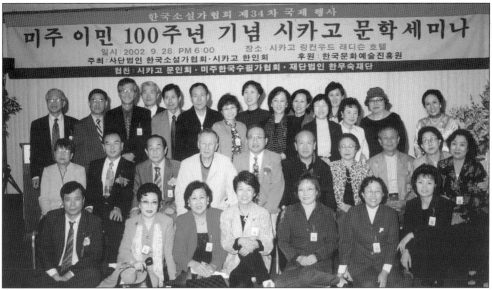

The Korean-American Association of Chicago invited a delegation of 40 members of the Korea Novelists Association led by Eul Byung Chung (fourth person from left in the second row) to visit to Chicago to hold a conference on "Immigrant Literature" to commemorate the centennial year of Korean Immigration to the United States. This event was sponsored by the Chicago Korean Literary Society, which is led by Sung Young Kang, president (second person from left in the second row) and the Korean Essayists Association of North America, which is led by Moses G. Myung, president (fifth person from left in the second row) in September 2002 at the Radisson Hotel in Lincolnwood. (Photograph by Young Sik Cho.)

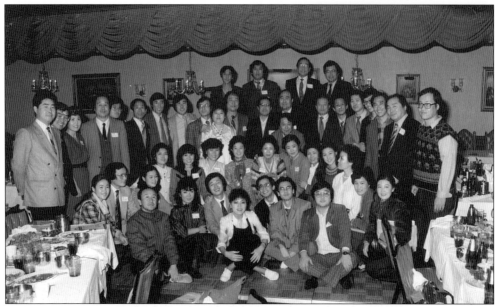

Yan Bian Singing and Dance Troop, a Korean-Chinese troop, visited Chicago in January 1985 and were hosted by members of the Korean-American community. (Courtesy of Chong Sik Kim.)

Several Korean community members dressed in Korean national clothing pose in front of Moo Goong Terrace, one of the Korean-American senior citizen housing centers in 1988. (Photograph by Chong Sik Kim.)

Right: Even though western-style weddings are popular among Korean Americans, traditional wedding outfits are often used. This newly wed couple in traditional costumes is waiting to bow to their parents. (Courtesy of Jenny Chang.)

Below: The Taekwondo Association of the Midwest's New Year's Party of 1982 is seen here. (Courtesy of Taekwondo Association.)

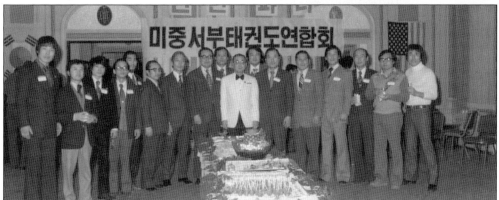

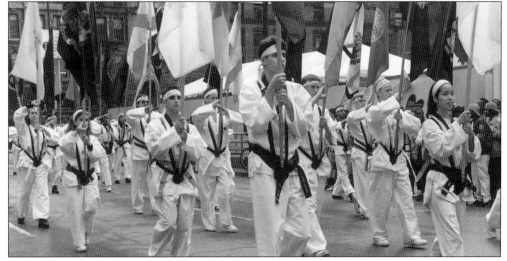

In August 1994, students from Kwon's Taekwondo paraded in celebration of Korea's co-hosting the 2002 World Cup. (Courtesy of Taekwondo Association.)

The officers of KAAC meet with Anthony Mc Gee and Elisa Fine Firlow from the Human Services Department of the City of Chicago in May 2002 to further discuss the association's After School Program. The City of Chicago awarded KAAC $40,000 for each of two years in order to properly launch the program. (Photograph by Young Sik Cho.)

These students are waiting to catch the bus to Navy Pier for the Korean-American Association of Chicago-sponsored summer youth program for students in grades one through eight. (Photograph by Young Sik Cho.)

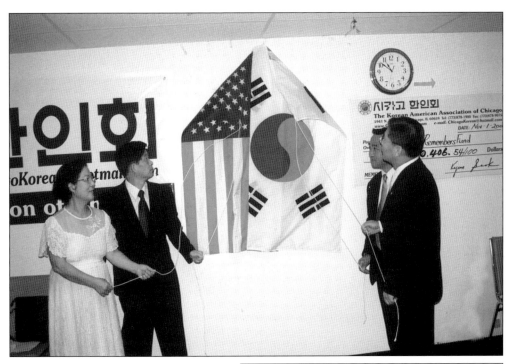

Above: President Seok of KAAC; Sang-Yoon Park, vice consul general from the consulate general of the Republic of Korea in Chicago; Wol Soon Bae, chairperson of the Korean YWCA; and Kyung Bok Lee, vice chairman of the KAAC Board are unveiling the plaque which cites the donors who contributed to the Special Relief Fund for September 11, 2001 victims. The contribution totaled $150,406.54. (Photograph by Young Sik Cho.)

Right: This is an invitation card for the photo exhibition. The image on the invitation card is a representation of a traditional "Bojahkee," which is a traditional Korean cloth used for wrapping gifts or personal belongings. It was also used as a form of luggage. The images of immigrants printed on the cloth represent the fact that the early Korean immigrants wrapped up their culture and heritage along with their possessions when they immigrated to the United States.

The Photo Exhibition

for celebrating

the 100th Anniversary

of Korean American Immigration

to the United States of America

January 13 – 24, 2003

The Centennial Committee of Korean Immigration to the United States - Chicago

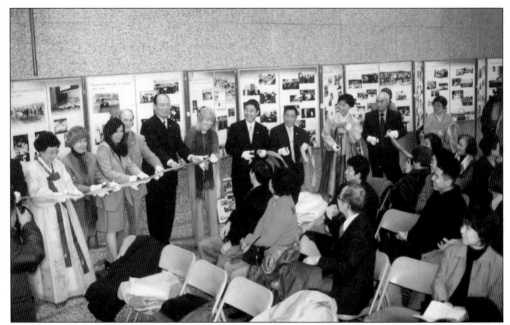

Hyuck Chun, co-chairman of the Korean Centennial Committee—Chicago chapter, (second person from right) poses at the ribbon cutting ceremony with the guests and photo committee members for the photo exhibition on January 13, 2003 at Richard J. Daley Civic Center. (Photograph by Young Sik Cho.)

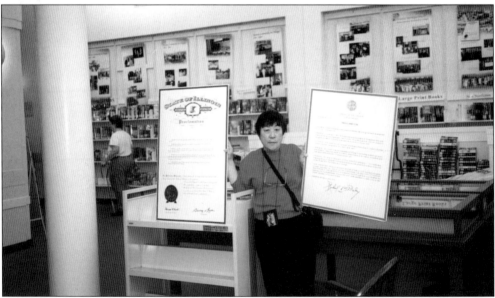

Chung Su Kim Yoon, a clerk at the Sulzer Library and planning committee member for the photo exhibition celebrating the 100th anniversary of Korean-American immigration, is holding a State of Illinois proclamation celebrating the arrival of the first Korean immigrants in the U.S. and Korean-American contributions in various fields, Governor George H. Ryan and Secretary of State Jesse White signed this proclamation on September 17, 2002, which marks 2003 as the year of Korean Immigration to the United States. (Courtesy of Chung Sue Yoon.)

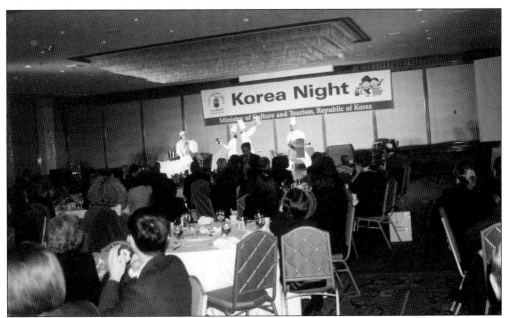

Nanta, a western performance style of Samulnori, is seen here played with four instruments while the performance group visits Chicago. Nanta means to recklessly strike, as in a slugfest at a boxing match. It is a non-verbal performance of reckless rhythms that dramatize customary Korean percussion in a comedy stage show.

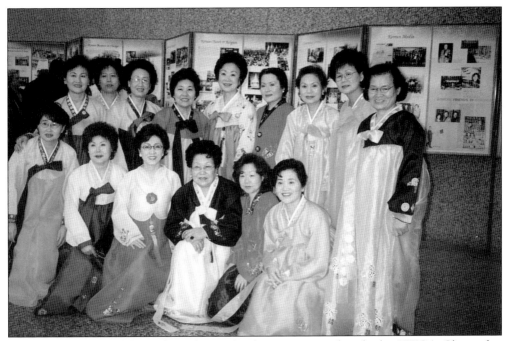

Dong Sook Jin, third from the right in the front row, posed with the YWCA Choir after performing at the photo exhibition in honor of the Centennial Celebration of the Korean Immigration to the U.S. at Daley Civic Center. She is the founder and the chairperson of the choir. This was their first performance outside of YWCA functions.

Korean-American Nurses Association Choir members pose with their choir conductor, Won Kee Ahn (second from the right, first row) on September 7, 2000 to commemorate their first choir foundation. (Courtesy of Haisook Kim.)

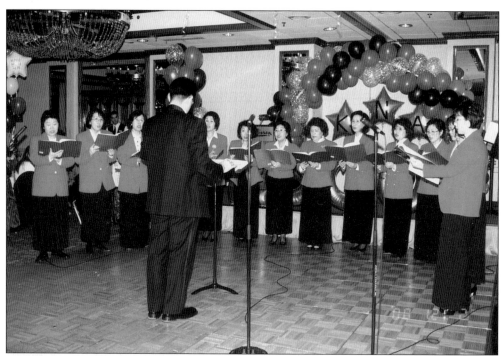

The Korean-American Nurses Association Choir's first performance was held at the Radisson Hotel for the 2000 Christmas party. It is the first choir formed from a Korean-American professional association.

Four

POLITICS

By the mid-1970s, the Korean-American population in Chicago increased substantially, becoming more visible with increased social and business activities while also becoming more politically active. Various associations, by profession and affiliation, began to be formed and the Korean-American Association of Chicago (KAAC), which was formed in 1964 to seek solidarity and promote friendship among Koreans, began to work more actively as the umbrella organization for all the other Korean-American organizations. While KAAC did not regard itself as a political organization, it was actively involved in solidifying Korean-American ethnic identity and advocating for Korean-American issues and the welfare of the community. It also developed important relationships with mayors especially the late Harold Washington and Richard M. Daley, and Gov. James R. Thompson, who all did a great deal to help the community and were strongly supported by the Korean-American community. The community tried to have its own voice in a multicultural society actively advocated for less restrictive immigration laws, the protection of the merchants on the South Side, family reunion for Korean American and North Korean separated family members, and increased employment of Korean Americans in public sector jobs.

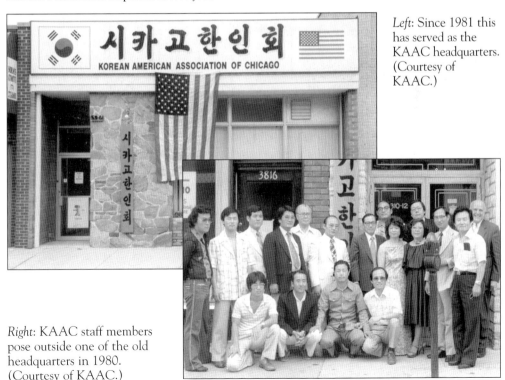

Left: Since 1981 this has served as the KAAC headquarters. (Courtesy of KAAC.)

Right: KAAC staff members pose outside one of the old headquarters in 1980. (Courtesy of KAAC.)

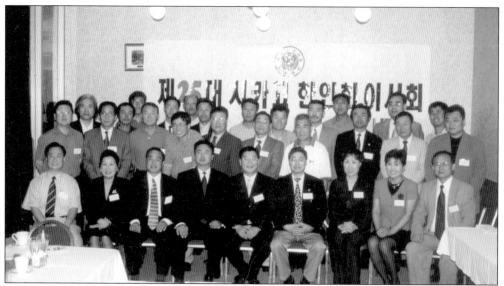

The 25th Board of Directors of the Korean-American Association of Chicago (KAAC), 2001. KAAC is the umbrella organization for the Korean community in the greater Chicago metropolitan area. The purpose of the organization is to create awareness of and maintain Korean-American rights, preserve Korean-American cultural heritage, improve the social status of Korean Americans, and help in the integration of Korean Americans into mainstream society. (Couresy of KAAC.)

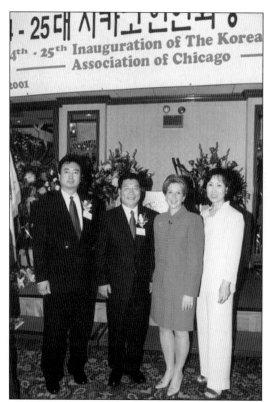

Lt. Gov. Corinne Wood meets with newly elected senior officers of the Korean-American Association of Chicago to celebrate their inauguration as the 25th group of officers for the term of July 2001–June 2003 at the Radisson Hotel in Lincolnwood. Pictured, from left to right, are: Jin Lee, vice president; Kyun S. Seok, president; Lt. Gov. Corinne Wood, and Kyu Y. Park, vice president of KAAC. (Photograph by Young Sik Cho.)

Key members of the Fund Raising Committee meet in 1980 to plan the purchase of the Korean-American Association building. The key members include Kie Young Shim, the 4th, 5th, and 13th president of the KAAC; and Chang Bum Kim, 15th president of KAAC. These committee members played an important role in purchasing the Korean-American Association's own building which was opened on August 15, 1981. (Courtesy of Kyung Sik Kwack.)

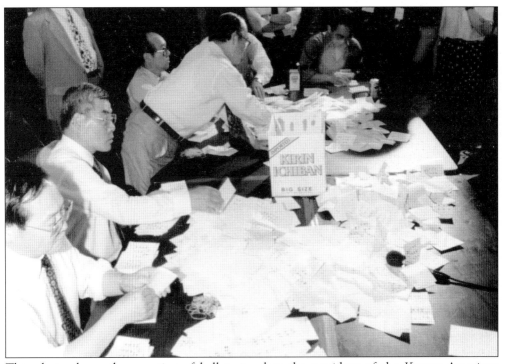

This photo shows the counting of ballots to elect the president of the Korean-American Association in the 1982 election. (Courtesy of KAAC.)

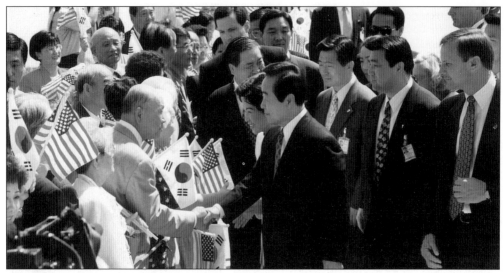

The 14th president of the Republic of Korea, Kim Young Sam, and the first lady (center) arrived at O'Hare International Airport in July 1995 for a two-day visit to Chicago. He was greeted by some members of the Chicago metropolitan area's 150,000-strong Korean-American community. President Kim was the second Korean head of state to come to Chicago after the Republic of Korea's first president, Syngman Rhee's visited in 1954. (Photograph by Chong Sik Kim.)

President Young Sam Kim visited Chicago in July 1995 and met with Jim Edgar, then-governor of Illinois. (Photograph by Chong Sik Kim.)

The 15th president of the Republic of Korea, Kim Dae Jung, greets Kyun Hee Park, the 24th president of the Korean-American Association of Chicago, at the Reception Hall in the Blue House in Korea in August 2001. President Kim also visited Chicago in March 2001. (Courtesy of Chang Yoong Lee.)

Paul Park meets with President Clinton at the Chicago Historical Society on Clark Street during his visit to Chicago after the election in 1992 to thank his supporters. Paul Park was a Democratic Platform Committeeman at the 1992 Democratic Convention in New York City. Clinton later appointed him as a board member of the Woodrow Wilson International Center. (Courtesy of Paul Park.)

Right: Young Hwan Cho is shown with Roland W. Burris, attorney general of the State of Illinois, in August 1994. Attorney General Roland Burris enabled many Korean-American organizations to obtain grants from the State of Illinois. (Courtesy of Young Hwan Cho.)

Left: Delegates pose at the Democratic National Convention in New York City in 1992. Pictured, from left to right, are: Pat Quinn, treasurer of the State of Illinois; and Young H. Cho. (Courtesy of Young Hwan Cho.)

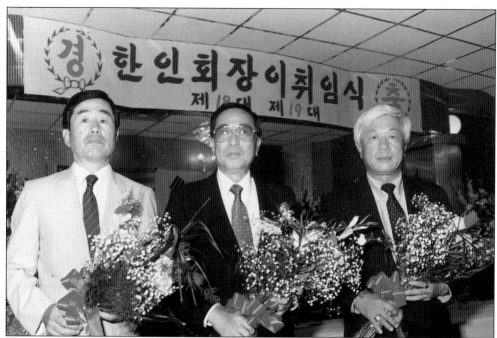

The 19th group of KAAC officers receives flowers after their installation in July 1989 at Bando Restaurant on Lawrence Avenue. Pictured, from left to right, are: Yung Hwan Kim, Hyo-Hyun Byun, and Hahk Su Jin.

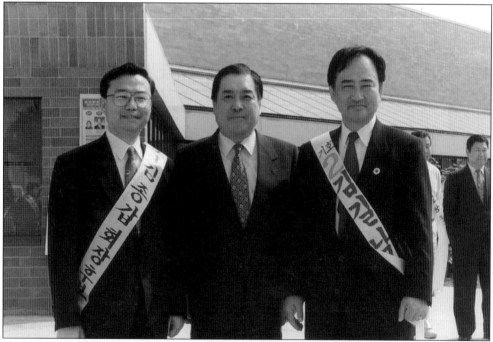

Consul general of Chicago of the Republic of Korea, Chang Ho Lee, poses with two candidates—Jong Gap Kim and Kil Nam Kim, who were running for the 21st presidency of the Korean-American Association of Chicago in June 1993. (Courtesy of KAAC.)

Right: The 14th presidency of the KAAC held its after-election party at Hwa Goong on Devon Avenue in 1978. (Courtesy of KAAC.)

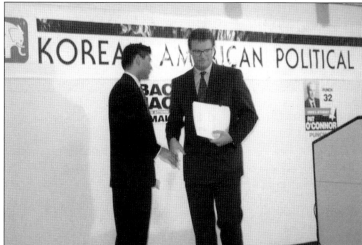

Left: Michael Cho, state attorney of Illinois, is shown introducing Jack O'Malley, a candidate to become attorney general of the State of Illinois, at a meeting of the Korean-American Political Forum in 1992 at the community center of Foster Bank. (Courtesy of Young Hwan Cho.)

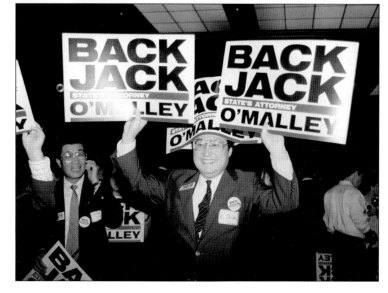

Right: Kee Young Shim, the first Korean-American attorney to open an office in downtown Chicago, is pictured rallying for Jack O'Malley's campaign in 1992. (Courtesy of Chong Sik Kim.)

The 1980 Korea Day Parade is shown here. Gov. James R. Thompson signed a proclamation on September 25, 1978 declaring it "Korea Day" in Illinois. This proclamation celebrates the birth of the Korean nation, which Koreans observe on October 3.

Late Woo Hang Kim, an Asian Advisory Board member for Mayor Harold Washing meets with the mayor and Senator Paul Simon at the Korea Day Parade in 1985. (Photograph by Chong Sik Kim.)

The 17th and 18th presidents of KAAC and Consul General Kyung Il Chung are welcoming Senator Paul Simon in 1986 at the reception in his honor. (Photograph by Chong Sik Kim.)

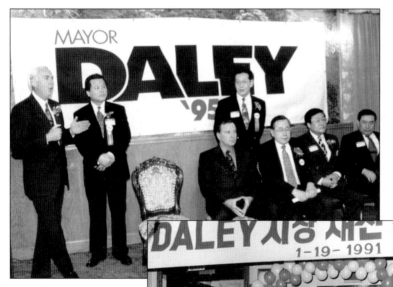

Pictured is a re-election rally for Mayor Richard Daley , 1995. (Courtesy of Chong Sik Kim.)

Korean-American leaders are pictured with Mayor Richard Daley during his re-election campaign in 1991. (Courtesy of Chong Sik Kim.)

Korean-American community members participate in Senator Charles Percy's campaign rally.

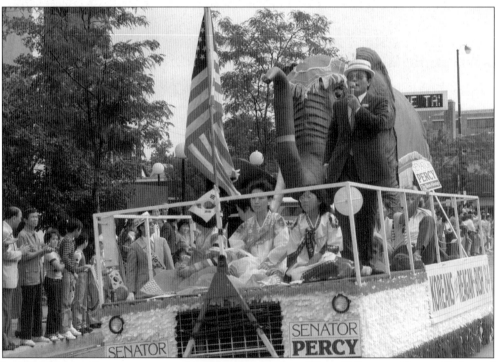

In 1984, Korean Americans campaigned for the election of Ronald Reagan, George Bush, and Senator Charles Percy on Lawrence Avenue. This photo was taken at a campaign rally for Senator Charles Percy. (Photograph by Chong Sik Kim.)

Chunghee Kim Kang is pictured with Gov. Jim Edgar after serving in 1991 as one of his Transition Team members. (Courtesy of Kwang Ja Koo Lee.)

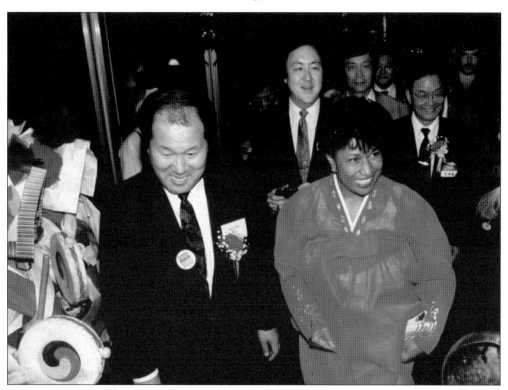

Senator Carol Moseley Braun meets with her Korean supporters. Sung Bae Kim, the president of the Korean-American Merchants Association, escorted her to the reception area in 1992. (Photograph by Chong Sik Kim.)

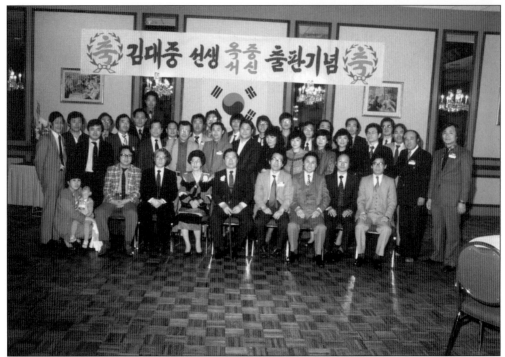

Kim Dae Jung and his wife (in the center of photo) visit Chicago in 1984 as the leading opposition candidate. During the visit, some Korean-American community members hosted him at a book-signing event to celebrate the publication of his new book containing letters from his supporters and personal correspondence. (Courtesy of the *Korea Daily*.)

Korean Americans celebrate their annual Korean Independence Day ceremony at the Radisson Hotel in Lincolnwood in 1979. (Courtesy of KAAC.)

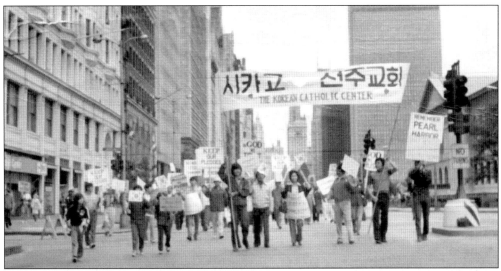

Korean Catholic Center members participate in a demonstration in 1974 against the withdrawal of U.S. troops from South Korea. The demonstration was held in front of the Consulate of the Republic of Korea in Chicago at 550 N. Michigan Avenue in 1974. (Courtesy of Korean Martyr's Catholic Church.)

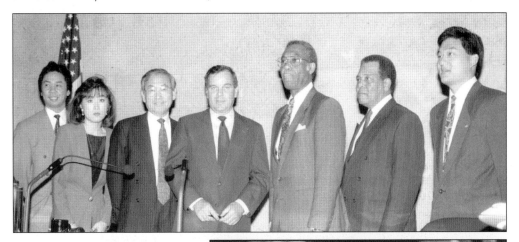

Above: Mayor Daley is here making congratulatory remarks at the Korean- and African-American Choir Festival, a peacemaking event with Rev. Eun Chul Cho and Charles Jurdan. (Photograph by Chong Sik Kim.)

Right: Mayor Jane Byrne visited the Korean food booth at the first Taste of Chicago in 1980. The festival was started by Mayor Byrne in that year. (Photograph by Chong Sik Kim.)

Chang Ho Lee, consul general of the Republic of Korea, meets with the officers of the Advisory Council on the Democratic and Peaceful Unification of Korea (ACDPUK), Chicago chapter. (Courtesy of ACDPUK.)

Soo Sung Lee, vice chairman of the Advisory Council on Democratic and Peaceful Unification of Korea visited Chicago in 1999 to attend Korea Unification Day in Chicago, which is an annual observation day of prayer and meditation for over ten million Korean families residing in Seoul, Korea and other American cities. (Courtesy of ACDPUK)

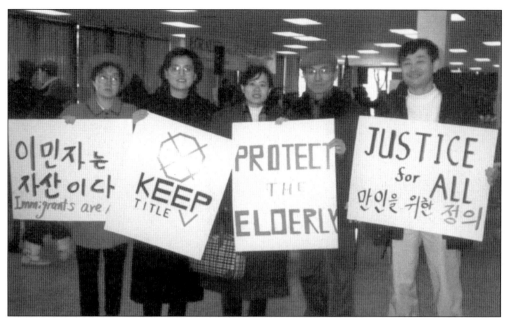

Korean-American Community Services (KACS) members participate in a political rally to benefit elderly immigrants in 1993. (Courtesy of KACS.)

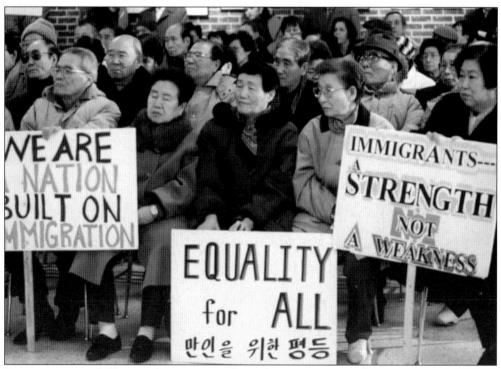

Senior citizens of Chicago from various Asian-American groups demonstrate against anti-immigration laws at Truman Community College in 1997. These laws were initially adopted in 1995 by the State of California and started to spread across the United States. (Courtesy of Korean-American Resource and Cultural Center.)

The Korean-American Association of Chicago (KAAC) called a meeting of Korean-American young professionals to the KAAC headquarters in December 2001 to discuss the possibility of forming a second generation leadership organization. This organization would promote better relationships with the non-Korean community and local, state, and federal governments. The organization could also guide the Korean-American youth groups and work on political empowerment. This young professional organization eventually became the Korean-American Coalition of Chicago. (Courtesy of *Korean Daily*.)

Consul General of Chicago Kyu Ho Choo awarded a medal to a Korean War veteran in October 2002. (Courtesy of the *Korea Daily*.)

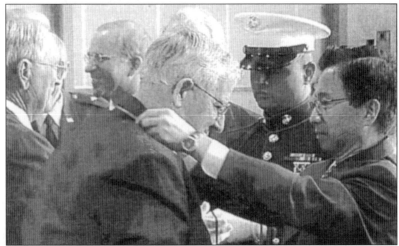

Thomas C. Ko, president of Korean Veterans Association in Chicago (KVAC), awarding medals to Korean War Veterans at the 50th anniversary of the Korean War in June 2000. (Courtesy of KVAC.)

Kil Nam Kim, the 21st president; Hyun Il Kim, vice president; and Master Duk Keun Kwon, the chairman of the board of the Korean-American Association of Chicago visit Mayor Richard M. Daley at city hall before the 1993 Korea Day parade. Police Superintendent Matt Rodriguez was presented with an honorary black belt degree in Tae Kwon Do.

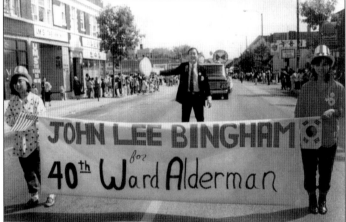

John Lee Bingham, a third-generation Korean American running for alderman in the 40th district, campaigns in the Korean community by participating in the annual Korea Day Parade in 1992. Patrick J. O'Connor defeated him. Two years later, he ran for State Rep. for the 34th district in 1994, but was not successful. (Photograph by Chong Sik Kim.)

Mayor Richard M. Daley and members of the Korean Women's Choir pose after the 1993 Korean Thanksgiving celebration in city hall in 1998. (Courtesy of Chong Sik Kim.)

67

Shinae Chun was the first Asian American cabinet member of the State of Illinois (director of the Illinois Department of Financial Institution, 1989–1991 and director of the Illinois Department of Labor, 1991–1999) and the highest-ranking Korean American in the Bush Administration (the 15th director of the Women's Bureau at the U.S. Department of Labor, 2001–.) (Courtesy of Shinae Chun.)

The Korean-American Coalition of Chicago (KAC–Chicago) seeks to build and strengthen the social, cultural, and professional ties among Korean Americans, and empower the community through advocacy, civic participation, and leadership development. Several members of the board of directors of KAC-Chicago welcome Charles Kim, executive director of the KAC from Los Angeles, California at the November 2002 reception held in his honor. Pictured, from left to right, are Cecilia Ham, Jeanny Yoon, YuKyung Choi, Edward Seward, and Charles Kim.

Northeastern Illinois University President Dr. Salme H. Steinberg receives the Grand Asian Award from the Asian American Coalition of Chicago during Lunar New Year's Celebration 2002 at the Hyatt Hotel in March. The Grand Asian Award is given to a non-Asian who has promoted the welfare of Asian Americans and has contributed a lot to the betterment of the Asian community. Each Asian community of the Coalition can nominate one candidate for this category. The Korean-American Community of Chicago (KAAC) nominated her for this award. (Photograph by Young Sik Cho.)

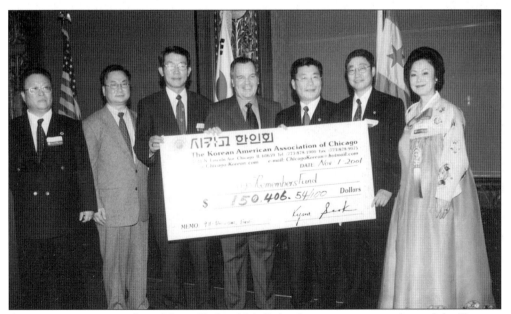

A presentation was made to Mayor Richard M. Daley by prominent members of the Korean-American community in the amount of $150,406.54 in support of the victims of the 9/11 tragedy. (Photograph by Young Sik Cho.)

Korean-American supporters for Blagojevich for governor of Illinois are seen here. (Courtesy of the *Korea Times Chicago*.)

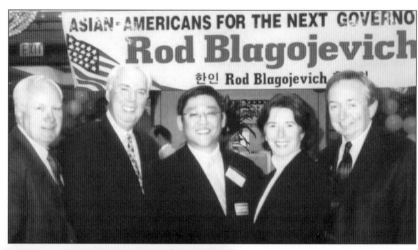

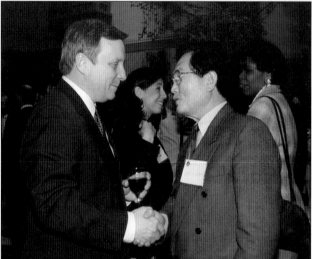

Left: Young Joon Chang, the 9th president of the KAAC, meets with Senator Richard J. Durbin. (Courtesy of Chong Sik Kim.)

Below: Officers from the Korean-American Citizens Coalition of the Midwest meet with Secretary of State Colin Powell in September 2001 to lobby on the issues of the reunion of North Koreans and Korean Americans separated from family members. (Courtesy of Kwang Ja Koo Lee.)

Five
BUSINESS

By 1975, the Korean-American population had reached such a size that a "Korean Town" was developed on Lawrence Avenue between Pulaski and Lincoln Avenue. Korean people were viewed as strong in stamina with unflinching tenacity, and have been characterized as "hardworking small business owners." Indeed, about 50 percent of all Korean-American families in Chicago are involved in small businesses with 25 percent in dry cleaning alone.

A large influx of Korean immigrants in the mid-1960s and 1970s resulted in a pool of highly educated men and women who were limited in English. As a result, labor-intensive jobs that did not require much English skill, such as small "mom and pop" businesses, became a natural evolution for these recent immigrants with enterprising spirits.

These pioneering merchants first opened their businesses in the Wrigleyville and Uptown areas of Chicago, where Korean immigrants first settled in the 1960s and 1970s. While the Korean Americans, and many businesses moved to north suburban Cook County, Korean wholesale and import and export stores still exist along Clark Street in the Wrigleyville area.

In the 1980s, a shift occurred and small Korean-American businesses began to cluster in the Albany Park area. In addition, more adventurous merchants initiated retail businesses on the South and West Sides of Chicago in predominantly lower-income African-American neighborhoods. By the early 1990s, Korea Town was established on Lawrence Avenue and approximately 800 Korean-owned stores could be easily identified in the Englewood, Roseland, 47th and Grand Boulevard, and Madison and Pulaski neighborhoods.

In the mid-1970s to mid-1980s, the wig business dominated the business life of Korean Americans. After this business peaked, Korean Americans went into dry cleaning, grocery, general merchandise, restaurant, and beauty supply businesses. Korean Americans in the Chicago area also started to become involved in hotel and banking businesses. Many of these businesses are now moving from Korea Town to the north and western suburbs.

Along with the positive growth came some negatives. Among the problems were the growing tensions between the African Americans and the Korean merchants that centered their trades in the African-American neighborhoods on the South and West Sides of Chicago. Because many Korean immigrants here started their businesses in poor, largely African-American neighborhoods, relations between the two communities were often tense.

The Korean-American community organized the Korean Merchants Association of Chicago (KAMAC) in April 1990 to represent and protect the interests of Korean-American merchants on the South and West Side of Chicago and to deepen and enrich mutual understanding between Korean-American merchants and community residents.

To accomplish one of KAMAC's goals, the organization encourages Korean-American merchants to reinvest in their respective communities and manifest good relations and feelings in the merchants toward African Americans. KAMAC members contribute to the communities in which they do business by giving alms to neighborhood churches and scholarship funds for the needy. Its annual Food Basket Program for the holidays has been successful and has finally established itself as one of the city's major and noteworthy events. KAMAC also has an outreach and advocacy program that helps prevent interracial confrontations and successfully dealt with the aftermath of the Bulls Championship series, beginning in 1992.

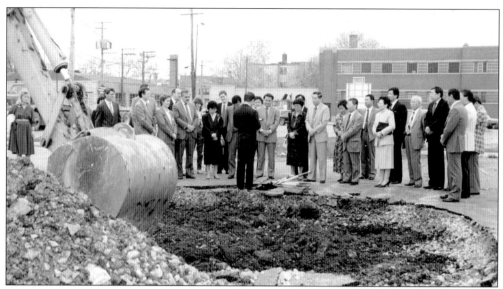

The groundbreaking ceremony is being conducted for the construction of Foster Bank in 1988 on Kedzie and Foster Avenues.

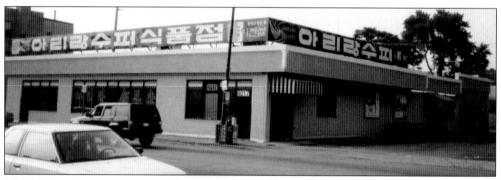

Arirang Supermarket was the first wholesale Oriental food market to open its door in 1970 by Young Kee Park. It was first located on Clark Street then moved to a new expanded site on Lawrence Avenue in 1985. Young Hee Park, the late Young Kee Park's wife, now owns this oldest and one of the largest Korean grocery stores, which also carries all other Asian grocery items. (Photography by Chung Sue Yoon.)

In the early 1940s, Fred Ohr opened a dental clinic on Clark Street. It was near Belmont Avenue, which was a hub for many Korean families. Dr. Ohr is now a semi-retired and distinguished dentist on Peterson Avenue. (Photograph by Myung Sook Jones.)

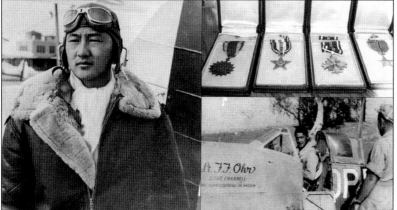

Fred Ohr is also a very highly decorated World War II fighter pilot, who was given the air medal, distinguished flying cross, bronze star, and also the silver star. (Courtesy of *KOAM Magazine*.)

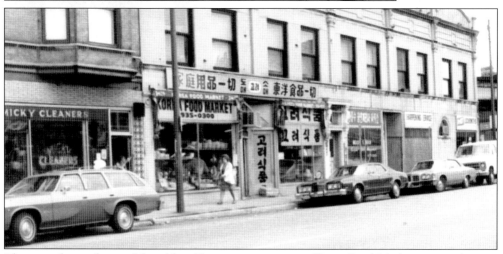

The store front of one of the oldest Korean grocery stores, Korea Food Market, is seen here in the 1970s on Clark Street. On its right, the office of Moon S. Han, CPA is shown; it is now located on Skokie Boulevard in Northbrook, Illinois. (Courtesy of Chung Sue Yoon.)

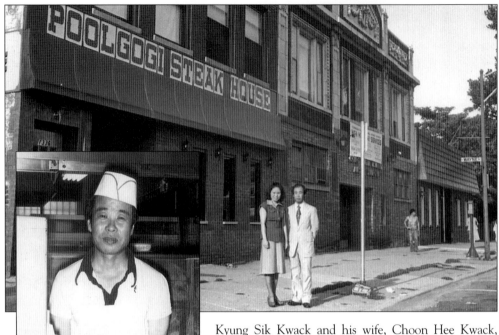

Kyung Sik Kwack and his wife, Choon Hee Kwack, stand in front of his famous Poolgogi Steak House, which was opened in April 1972 in downtown Chicago. This successful steakhouse helped to popularize Korean food, especially Poolgogi (Korean style B-B-Q beef) and Bibeambop (steamed rice with beef and vegetables). He started his Korean restaurant by introducing and offering free samples of food, which attracted non-Korean customers. He used his wealth to sponsor many major Korean-American community cultural events, including Korean wrestling demonstrations and actual competitions at Lake Michigan beach in 1979 and 1980, inviting wrestling champions from South Korea. (Courtesy of Kyung Sik Kwack.)

Edward Rim of Wauconda, Illinois, founded Goldman Dental Products, Inc. in 1979. Today, 35 companies are producing dental instruments and distributing their products all over the United States. (Courtesy of Edward Lim.)

Chade Fashions, Inc., established in 1972, specializes in importing and manufacturing women's hairpieces. Relocated to its expanded Niles company site from Pulaski Road in 2002, it is busily addressing the ever-increasing demand for women's hair apparel in the North American markets. "New Born Free" and "Amour" are the nationally recognized trademarks of Chade Fashions along with hairpieces and various hair ornaments. (Courtesy of Chade Fashions.)

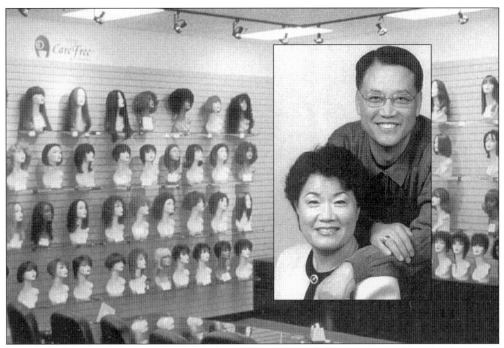

Established in 1975 by James Park, Alicia International, Inc. is one of the largest trend setting import, distribution, and wholesale companies carrying wigs, hair extensions, hair pieces, and hair accessories, leading the market with their "Carefree Collection." (Courtesy of Alicia International.)

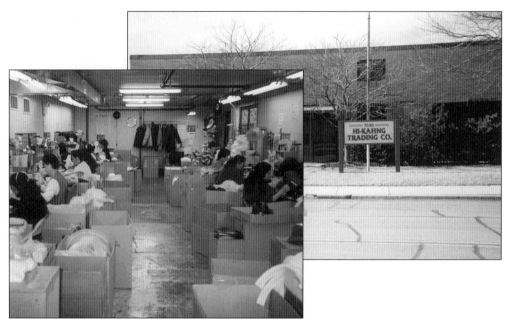

Hi-Kahng Trading Co. opened in 1967 on Lincoln Avenue importing wigs from Korea. Kahng expanded his business to a bigger place in the Belmont and Ravenswood area. During the 1980s when the wig market declined, he started selling sunglasses and shoes; he finally moved to the church hat making business, which gave him much success. His business is now located in Niles, Illinois. In 1990, Edward Kahng, his son and an attorney at law, joined his company and soon became the president of the Hi-Kahng Trading Company, which employs over 70 people. The company is now looking into manufacturing.

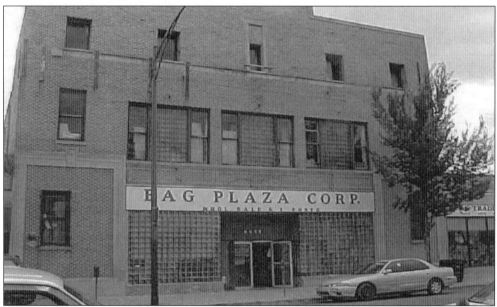

The Bag Plaza Corporation on Clark Street was established in 1976 by Jung Gu Park. The company specializes in general merchandise such as handbags, hats, custom jewelry, and other gift items which were first sold with wigs and other hair pieces from his company. (Courtesy of Bag Plaza.)

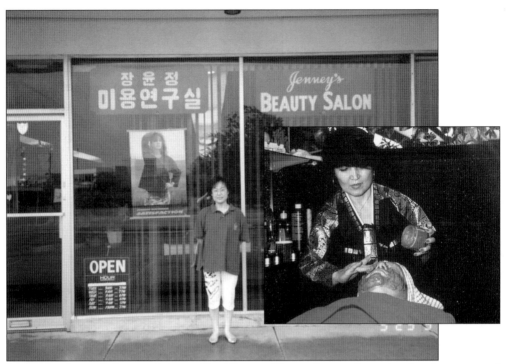

Pictured is Jenney's Beauty Salon in Des Plaines, Illinois. Jenney Jang also distributes natural beauty products all over the Midwest. (Courtesy of Jenny Chang.)

Kokere Mandoo Restaurant on Lawrence Avenue is pictured here in 1987. This was their first restaurant and it has since been moved to a new location on Lawrence. Kokere Mandoo specializes in dumplings. (Courtesy of Northshore Korean School.)

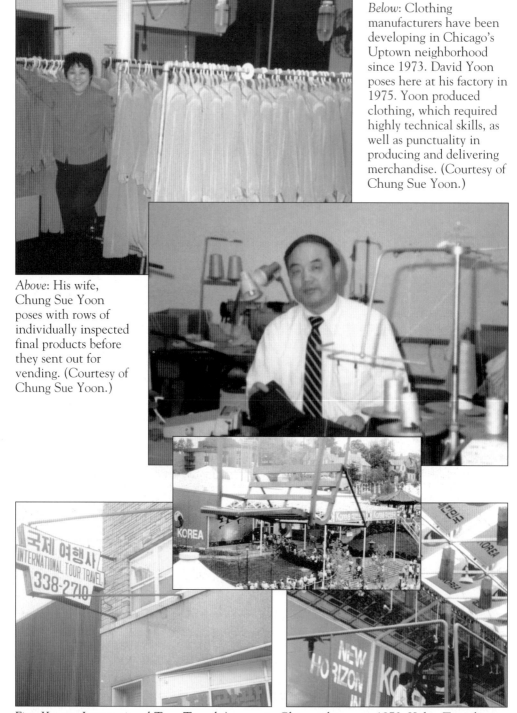

Below: Clothing manufacturers have been developing in Chicago's Uptown neighborhood since 1973. David Yoon poses here at his factory in 1975. Yoon produced clothing, which required highly technical skills, as well as punctuality in producing and delivering merchandise. (Courtesy of Chung Sue Yoon.)

Above: His wife, Chung Sue Yoon poses with rows of individually inspected final products before they sent out for vending. (Courtesy of Chung Sue Yoon.)

First Korean International Tour Travel Agency in Chicago began in 1970. Kukje Travel Service, established by Sung Young Kang, is the first travel agency that offered international tour services in Chicago. Shown in the pictures are group tours to the World Expo of 1979 in Nashville, Tennessee arranged by the Kukje Travel. (Courtesy of Kukje Travel Service.)

78

Jim Hwang, starting with only $300 in 1970, became the first Korean-American GM (General Motors) dealer in the United States. In 14 years, he built up a million dollar-plus business. (Courtesy of Chong Sik Kim.)

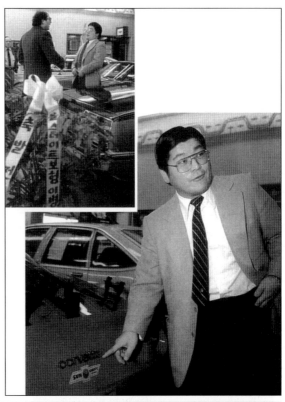

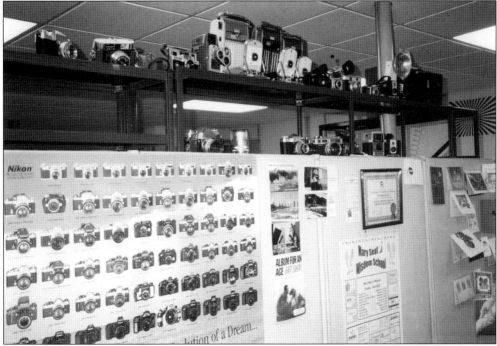

Art Shay introduced NCS Camera Service in Morton Grove, Illinois to the *Chicago Tribune* for its high quality service. (Courtesy of NCS Camera.)

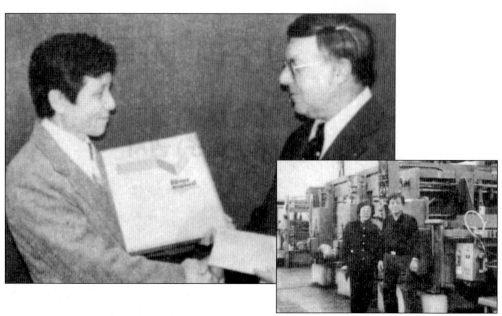

Above: Tae Young Kim founded the box company KIMSUCO in 1975, and was given a citation for excellence in business. (Courtesy of KIMSUCO.)

Left: Dr. Chang Bok Lee was the first Korean ophthalmologist to practice on Michigan Avenue in Chicago. He came to Chicago in 1966 after graduating from Yonsei Medical School. He enjoys a large practice in Chicago and is a violinist with one of the suburban district orchestras in his spare time. (Courtesy of Myung Sook Jones.)

Below: Members of the Korean-American community celebrate the opening of the Lucky Goldstar branch office in Chicago. Pictured, second from the left, is Jong Su Hahm, the first director of the branch. (Courtesy of Kyung Sik Kwack.)

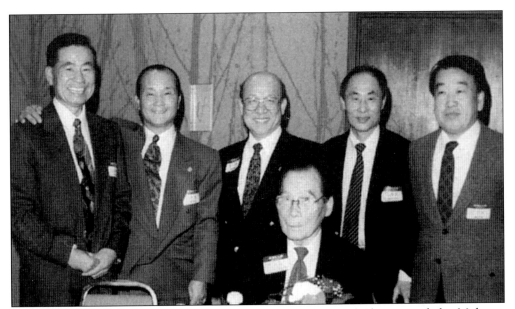

Some members of the Korean-American Dental Association of Chicago and the Midwest, U.S.A. (KADA) pose with their advisor, Dr. Paul Chung (seated) at the inaugural meeting establishing KADA on December 13, 1992 at the Best Western in Shaumburg, Illinois. Pictured, from left to right, are Choon Woo Lee, Ho Won Kim, Kee Chul Park, Hyung Yul Baik, and Woon Kyung Kim. (Courtesy of KADA.)

Tae Hoon Jhin established Jinny Beauty Supply Company in 1982. Located on Kimball Avenue, it is the largest ethnic beauty supply and general merchandise distributor in the world with over 16,200 different products as its inventory selection and dealing with over 250 manufacturers and vendors domestically and internationally. Jinny Beauty currently employs over 120 people and has branch office in Atlanta, Georgia and plans to open an office in Miami, Florida. (Courtesy of Jinny Beauty.)

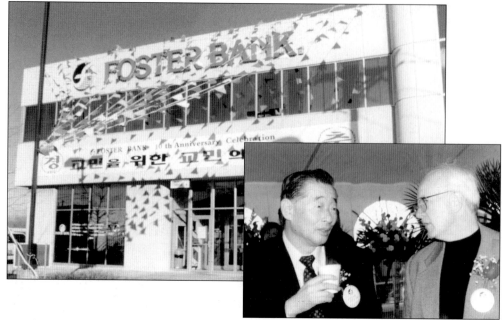

The First Korean Bank in Chicago, Foster Bank was founded in 1989 by Kun Chae Bae, president of KM Ventures Inc. He also owns Radisson Hotel, several golf courses, and several TV stations including Channel 28 in the Chicago metropolitan area. Through the banking business, he believed he could help his fellow Korean Americans prosper as well. Alderman Patrick J. O'Connor, also a vice president for community and legal services at Foster Bank, is shown with Mr. Bae. (Courtesy of Foster Bank.)

The first Korean-owned all-service eye-care establishment, Lawrence Vision Center, was opened in Korea Town on Lawrence Avenue in 1977. Byung Y. Min and his wife (third and fourth from left) pose with eye doctors in front of their store's showcases. (Courtesy of Lawrence Vision Center.)

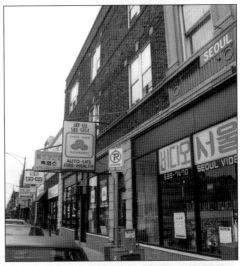

Above: Dr. Rak Woo Cha and his wife pose in front of their building. They have owned Cha Realty, Cha Realty School, Chicago Appraisal Co., and Lincoln Currency Exchange since 1980. (Photograph by Chung Sue Yoon.)

Right: Various Korean businesses in the heart of Korea Town's Albany Plaza on Kedzie and Lawrence Avenues (Seoul Drive) are pictured. The video rental business is also very popular among Korean Americans. (Courtesy of the *Korea Daily*.)

Below: Chong Sik Kim stands at his Lawrence Photo Services on Lawrence Avenue in Korea Town. He opened his studio in 1975 and ran the business until he moved to Arizona in 2002.

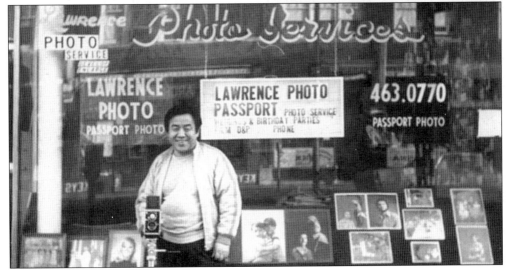

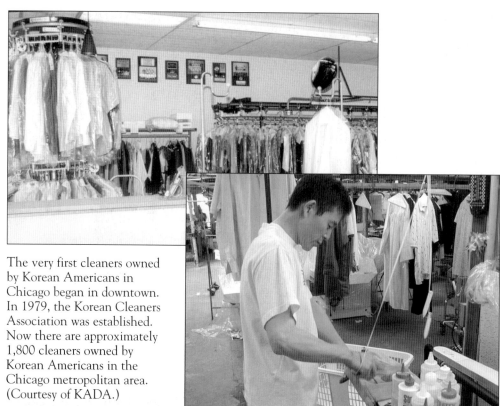

The very first cleaners owned by Korean Americans in Chicago began in downtown. In 1979, the Korean Cleaners Association was established. Now there are approximately 1,800 cleaners owned by Korean Americans in the Chicago metropolitan area. (Courtesy of KADA.)

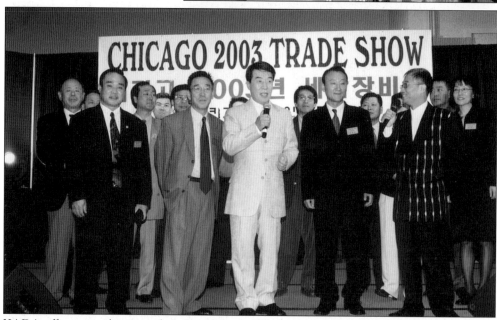

KADA officers are shown at their first Chicago Trade Show in Stephens Convention Center on May 3, 2003 To make the first trade show special, KADA invited a popular and famous Korean singer, Dae Kwan Song (middle, first row), to entertain the participants. On the singer's right is the 16th president of KADA, Sung Do Kang. (Courtesy of KADA.)

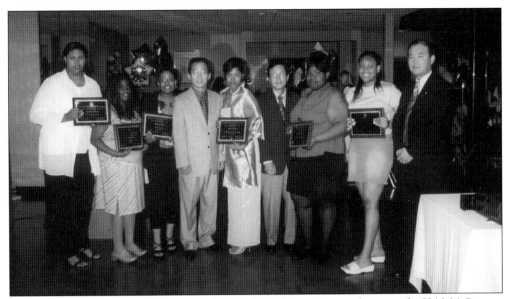

The Chicago Korean Beauty Supply Dealers Association along with KAMAC area representatives presented over $15,000 in scholarship awards and plaques to 30 graduating seniors in May and June of 2002 at the 12th Annual Scholarship Awards. Awards were presented for academic achievement, community service/leadership, and most improved student. (Courtesy of KAMAC.)

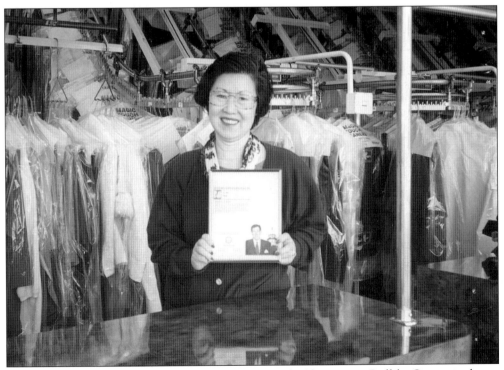

Young Sook Kim, the former owner of Magic Touch Cleaners in Buffalo Grove, is shown holding a citation of exemplary business from the city. (Courtesy of the *Korea Daily*.)

Each year, major Korean companies come to Chicago to interview Korean-American and American graduates for jobs with Korean companies. These interviews have been very popular in the Korean-American community and have been a source of employment for Korean Americans educated in the United States. In addition, Koreans who have studied in the U.S. are often recruited before they go back to Korea at these same job fairs. (Courtesy of the *Korea Daily*.)

KAMAC awarded scholarship to promising students from Chicago area schools. (Courtesy of KAMAC.)

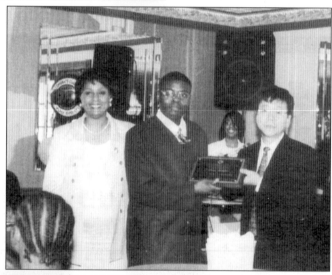

Below: This photo is from a cultural fund raising event in 2002. The S.K. Foundation, established in memory of Steve Kang, has helped many students in arts, sciences, and humanities. (Photograph by Chung Sik Kim.)

Dae Young Chong is the president of U-Jin Oriental Herb, which he opened in 1984. His practice has been very successful and he has served as the chairman of the election committee for the KAAC. (Photograph by Chang Yoong Lee.)

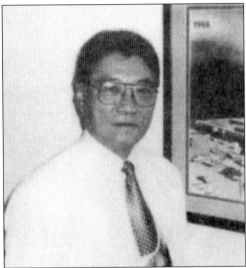

Illinois Herbal Medicine Association (IHMA) was established in 1994. Jong Su Kim, the president of the organization is shown in the picture at left. (Courtesy of IHMA.)

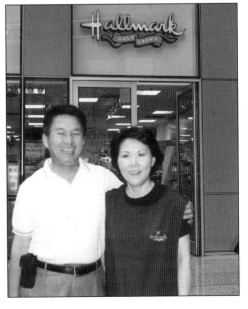

Kee-Nam Chang and his wife pose in front of one of their Hallmark stores in Chicago. They own all of the six Hallmark stores in the downtown Chicago area. (Courtesy of the Kee-Nam Chang.)

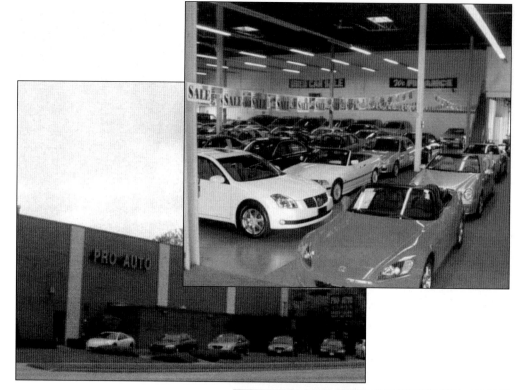

Pro Auto was started as an automobile leasing company on Lincoln Avenue by Sangkook Nam in 1987. It has grown to become one of the largest independent automobile dealerships in the Chicago area. It is located in Lincolnwood, Illinois and has a multi-ethnic clientele. (Courtesy of Pro Auto.)

Auto Plaza is a car dealership, which was opened in 1997 by Richard Park (above, left). It sells a variety of new and used cars. It is located on Lawrence Avenue in Chicago. (Courtesy of Auto Plaza.)

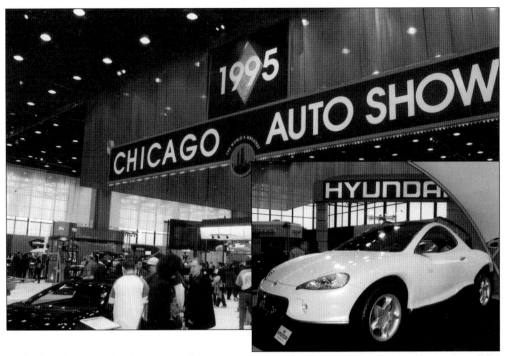

Each year, the Hyundai Corporation has participated in the Chicago auto show and its automobiles have been well received by the public attending the show. (Courtesy of the *Korea Daily*.)

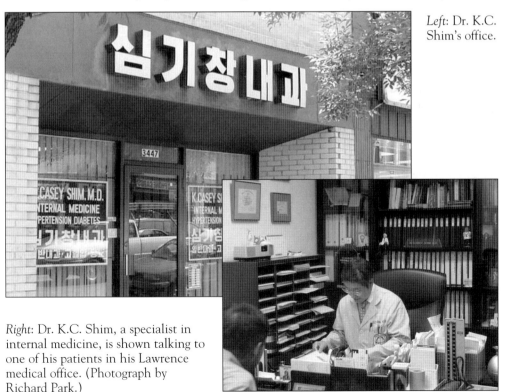

Left: Dr. K.C. Shim's office.

Right: Dr. K.C. Shim, a specialist in internal medicine, is shown talking to one of his patients in his Lawrence medical office. (Photograph by Richard Park.)

Wan Sun Tae (sixth person from the right), president of the Chamber of Commerce of the Republic of Korea, visited Chicago in 1975 and met with members of Chicago's Korean-American Chamber of Commerce (KACC). They pose together here during a reception in Mr. Tae's honor. (Courtesy of KACC.)

Jiyong Lee (center) began his career with State Farm Insurance Company in May 1971. He started a branch business, which is now located on Lincoln Avenue in Chicago. He led his agency to be ranked number one in the nation for Life Protection in 2002. (Courtesy of State Farm Insurance.)

Six
EDUCATION

Education has always played a major role in Korean-American society. Beyond the standard American curriculum of reading, writing, and arithmetic, Korean-American children gather each Saturday and Sunday in church schools to learn about their heritage, language, and history. Beyond basic education, Korean Americans are also involved in research and higher education programs throughout the Chicago area. In this section, Korean-American youth, 1.5 and 2nd generation photographs highlight their progress towards increased self-awareness and cultural identity in the Chicago metropolitan area.

Korean Americans in the Chicago area are present in almost every type of research lab and in academic pursuit. By the end of the 20th century, their numbers have surpassed the thousands. Pictures of a few pioneers in their field are exhibited here.

Of the several colleges and universities in the Chicago area, North Park University has organized an annual Korean symposium for more than ten years. Northeastern Illinois University has an academic degree-conferring program. Northwestern University has also sponsored symposiums dedicated to the Korean-American experience for several years. On every campus, there are literally thousands of Korean-American students and international students from Korea.

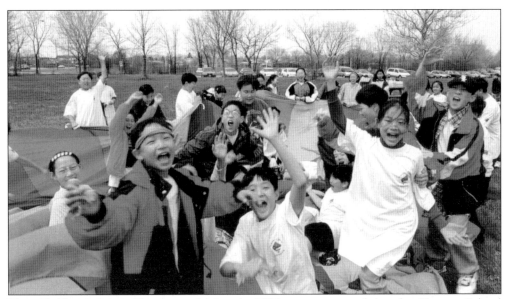

The Children's Mini-Olympics of May 4, 1986 was sponsored by the Korean School Association of Midwest, U.S.A. (KSAM) in order to celebrate the 1988 Seoul Olympics. Over 1,000 children gathered at La Bagh Woods Forest Preserve in Chicago. They participated in various games and activities. (Courtesy of KSAM.)

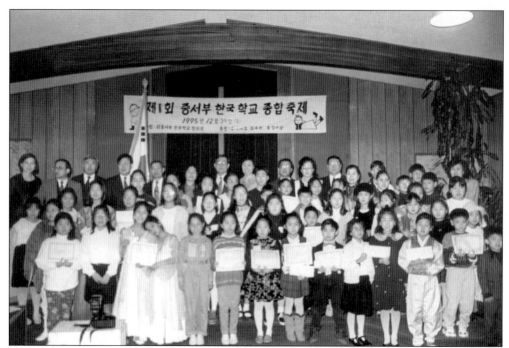

At an end-of-the-year Holiday Festival for Children in December 1995, students are encouraged to perform various special talents that they have developed during the school year. This festival is sponsored by the Korean School Association of Midwest, U.S.A. (KSAM) and the consulate general of the Republic of Korea and is open to students from any Chicago-area Korean School. At the end, the best performers win scholarships and presents. (Courtesy of KSAM.)

At the same festival, three boys demonstrate how to fly Korean kites. (Courtesy of KSAM.)

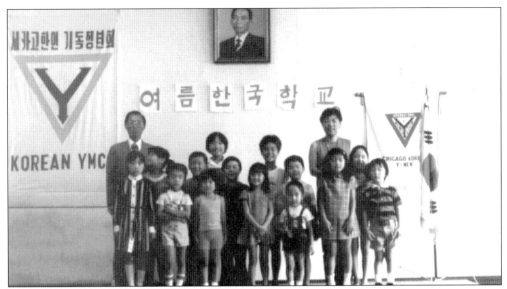

Some Korean schools are even open during the summer. Here are the best students from Chicago's first established Korean school, Chicago Korean School, at the end of the summer school ceremony of 1974. (Courtesy of KSAM.)

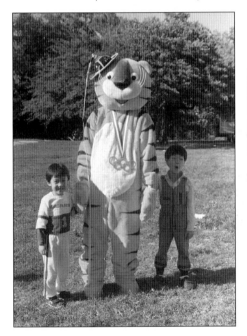

Left: At the Mini-Olympic Game in May 1986, two children posed with Hodori, the 1988 Summer Olympic Mascot. (Courtesy of KSAM.)

Right: Every June, KSAM hosts an assembly to recognize the best culture performance of each member school's students and also to show the parents and the public what they have accomplished. (Courtesy of KSAM.)

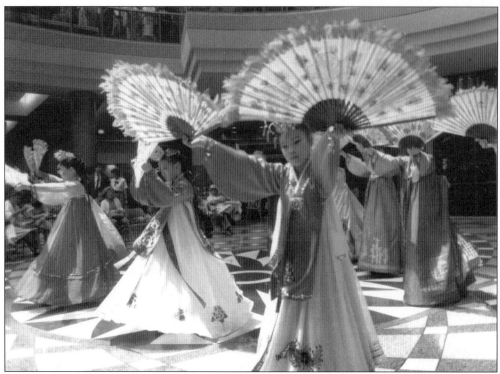

Korean Education also extends beyond the boundaries of the Korean community. Here, students perform for the state's Asian-American Heritage Month festival at the Thompson Center in May 1984. (Courtesy of the *Korea Times Chicago*.)

Here, students from the Canaan Korean School perform at the Northbrook Library in Northbrook, Illinois for the Korea Fest in May 1995. (Courtesy of Canaan Korean School.)

At the Annual Scholarship Ceremony in 1997, the Korean School Association of Midwest awarded scholarships for academic excellence to one student from each member school at the end of the school year in June. (Courtesy of KSAM.)

This future leader was the winner of the first annual Speech Contest sponsored by the Advisory Council on Democratic and Peaceful Unification of Korea, held at Niles Korea School on August 5, 2000. Niles Korean School is the largest Korean school in the Midwest with about 500 students. (Courtesy of ACDPU.)

This float was present at the 1982 Celebration of the Centennial Anniversary of U.S.-Korean Diplomatic Relations in May 1982. Here, students from various Korean schools in the Chicago metropolitan area participate in the parade. (Courtesy of Chong Sik Kim.)

These are some of the submissions for the 2001 Annual History and Culture Fair. Each Korean school in the Midwest sends in their best entries or participates in a cultural performance show. Every student who enters receives a prize for participating. (Courtesy of KSAM.)

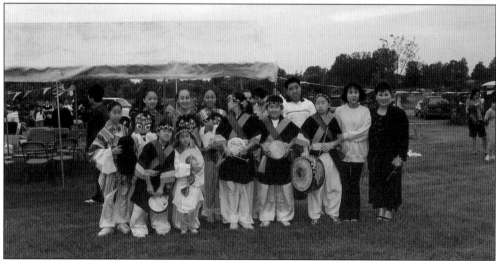

Kansas Korean School's traditional Korean Dance Team came to participate in the Fair in 2002. (Courtesy of KSAM.)

On April 27, 1995, Korean American students brought funds from their piggy bank savings to support Korean language as a subject of the SAT (Scholastic Assessment Test) II Subject Test. The amount given was $101.92. Students shown are Jin Young Kim (Northbrook Jr. High School, 6th Grade), her sister Jae Young Kim, and Kil Won Yook, the chief editor of the *Korea Times*. (Courtesy of KSAM.)

Pictured are students from the Chicago Korean School. The teacher, Esther S. Yoon, was a previous student in the old Chicago Korean School. She became a special education teacher at New Trier High School in Wilmette, which is ranked as one of the top high schools in the country, and came back to her Saturday Korean School to teach Korean American children Korean language and culture. (Photograph by Chung Sue Yoon.)

This is a group photo of participants at the 16th annual National Association for Korean School conference, held at O'Hare Marriott Hotel in Chicago, August 1998. They represent over 1,000 Korean Schools from across the United States. They gather every year to discuss the progress of Korean language, history, and culture education and to develop the curriculum. (Courtesy of National Association for Korean Schools.)

The Korean-American Scholarship Foundation for the Midwest Region (KASF) awards $1,000 to college students and $500 to high school students to encourage hardworking students to perform at their high level of scholarship. (Courtesy of KASF.)

Asian Language Course Offerings

CHINESE

- **FL-CHIN-101 Chinese I, 3 cr.** Development of basic skills in listening, speaking, reading, and writing. Cultural appreciation.
- **FL-CHIN-102 Chinese II, 3cr.** Continuation of FL-CHIN-101. *Prereq.:* FL-CHIN-101 or equivalent.
- **FL-CHIN-103 Chinese III, 3cr.** Continuation of FL-CHIN-102. *Prereq.:* FL-CHIN-102 or equivalent.

JAPANESE

- **FL-JPN-101 Japanese I, 3cr.** Development of basic skills in listening, speaking, reading, and writing. Cultural appreciation.
- **FL-JPN-102 Japanese II, 3cr.** Continuation of development of skills in listening, speaking, reading, and writing. Cultural appreciation. *Prereq.:* FL-JPN-101 or equivalent.
- **FL-JPN-103 Japanese III, 3cr.** Continuation of development of skills in listening, speaking, reading, and writing. Cultural appreciation. *Prereq.:* FL-JPN-102 or equivalent.
- **FL-JPN-104 Japanese IV, 3cr.** Continuation of development of skills in listening, speaking, reading, and writing. Cultural appreciation. *Prereq.:* FL-JPN-103 or equivalent.

KOREAN MINOR

A minor consists of 21 credit hours to be selected in consultation with a department advisor. Students in Early

After the 1997 inclusion of Korean in the SAT II Subject Tests, Korean studies began to boom in Chicago. Northeastern Illinois University (NEIU) created the first and only Korean Minor Program and Korean Summer Institute program in the Midwest.

Summer Institute in Intensive Korean

June 2 to August 8 1997

Northeastern Illinois University

College of Arts & Sciences

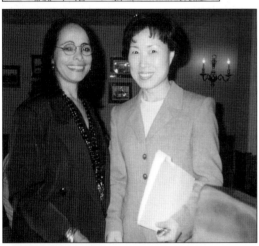

Left: At the 1999 Korean Summer Institute reception, Murrell Duster, dean of academic development, who helped to create the Korean Program at NEIU and Kyu Park, director of the Institute, pose for the event picture.

Below: NEIU Korean American Student Association (KASA) sells Korean Food at the International Day Festival in November 1999.

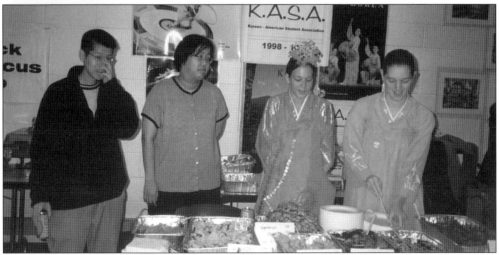

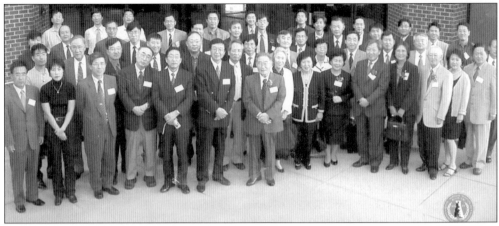

Symposium on telecommunication session.

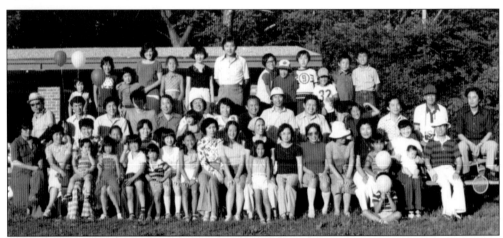

Family picnics of Korean Architects Association.

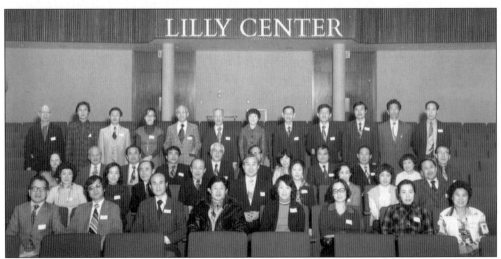

Korean Pharmaceutical Association of Chicago visiting Eli Lilly.

100

The Symposium on Korean Americans at North Park University is seen here. The Center for Korean Studies at NPU holds the Korean Symposium annually. The third person from the right is Dr. Ho-Youn Kwon, director of the Center for Korean Studies.

David Soosang Kang is seen here at Rush Medical School. Dr. D. Soosang Kang, professor of Pediatrics and director of Biochemical Genetics at Rush Medical School, discovered protein bound homocysteine (1979) to the ranks of cholesterol for its role in developing severe arteriosclerosis.

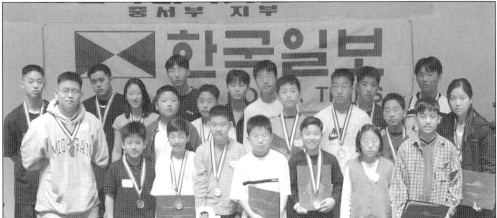

The Korean American Scientists and Engineers Association has been holding an annual Math Competition since April 2001. This year's Grand Champion trophy and scholarship went to Andrew Kim, senior in Glenbrook South High School and he will be attending Duke University in the fall of 2003.

Chunghee Kim Kang is posing in her laboratory at the Esmark Company after receiving the issuance of her latest patent "Tenderizations of Meat by Natural Enzyme Control" (1971).

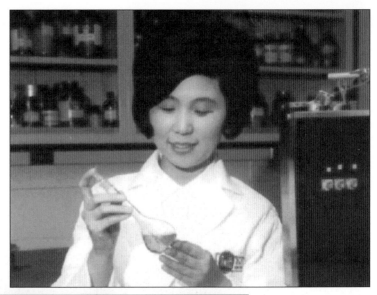

Young Ock Cho is a cancer researcher and associated professor at the University of Chicago.

Dr. Yum came to the U.S. in 1919 and was the first Korean student at the University of Chicago and was also the first Korean to have received a Ph.D. from the University of Chicago in Psychology in 1930. He went back to Korea to teach at Seoul National University in 1946. He came back to the U.S. to gather his family to move back to Korea with him for good but the Korean War stopped him. He taught at U.C. Berkeley for a while then came back to Chicago and spent his last days in Hyde Park, Illinois.

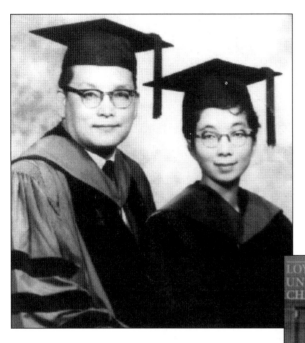

Dr. Soon D. Koh is the first Korean to have received a Ph.D. in Psychology from Harvard University (1959). Dr. Tong-He Koh is the first Korean woman to have received a Ph.D. in Psychology in the U.S. (Boston University, 1960).

Below: Daniel Booduck Lee is a professor of Social Work at Loyola University.

Below: Kwang Chung Kim is a sociologist on Immigrant Studies at Western Illinois University.

Jin Wook Choi (second person from right), professor of Economics at De Paul University is shown with participants at the Symposium on Korea at the college of Du Page on May 8, 1999. Pictured, from left to right, are: Professor Dong Whan Park (Political Sciences, Northwestern), Consul General Jong Kyu Byun, and president of Du Page College, Mike Murphy. (Courtesy of ACDPUK.)

Korean-American college students meet with Korean university students who came to study in Chicago during their summer vacation to exchange ideas to better understand each other's cultures. These students also use their time together to exchange oral communication skills in English and Korean. The Korean-American Association of Chicago sponsored this exchange visit in 2001 at KAAC headquarters. (Photograph by Young Jin Kwack.)

Dr. Howard Jeon and Dr. Jin-Moon Soh, president of KADA–Chicago (from left) with UIC dental students at the correction session during the March 2000 Dental Seminar at UIC campus. (Courtesy of KADA.)

Dr. Dong Man Cha established the Language and Math Academy on Lincoln Avenue on Chicago's Northwest Side in 1981, as an after school program for students in the 5th grade through high school. He also developed a correspondence mail study program, which he marketed not only in the U.S. but also even in Europe and Asia. (Courtesy Dong Sook Jin.)

Chan Eung Park, a professor of Korean Literature at Ohio State University, also teaches students how to perform Pansori. Professor Park came to Chicago to perform in April 1998 for the SAT II Korean Seminar at Radisson Hotel in Lincolnwood. (Courtesy of Korean School Association of Midwest.)

The three Chicago Public Library's assistant commissioners posed for the cover of the June 1995 issue of the *Library Journal*. Pictured, from left to right, are: Charlotte Kim, Alice Scott, and Emelie Shroder. Charlotte Chung-Sook Kim is assistant commissioner of neighborhood services at the Chicago Public Library, a position she has held since 1989. She is responsible for the overall operation of 77 branch and regional libraries, bookmobile services, and renovation of 42 branch libraries.

Dr. Charles Hang Tai Rhee was the first Korean American dean of an American college. He was a professor of Political Science and dean of George Williams College in Downers Grove, Illinois. In 1970, he was also given the Golden Apple Award for teaching excellence at the college. He was married to Susan Rhee who is counseling, transfer, and advising services administrator of the College of Du Page in Glen Ellyn, Illinois.

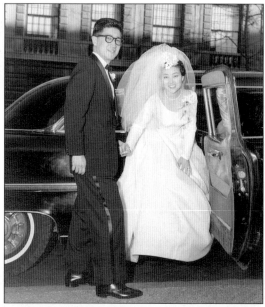

This picture shows Professor Rhee getting married at Columbia University chapel in New York in March 1962. (Courtesy of Susan Rhee.)

Below: Professor Susan Rhee was pictured with Ann Landers at the National Counseling convention. Professor Rhee served as the chair of the convention in 1983. (Courtesy of the *Korea Times Chicago*.)

Seven
RELIGION

Emigrating from ones home and building a community and life in a foreign world is an incredibly trying experience for every immigrant. Koreans are no exception. Often times, religion is vital to the development of a community. Thus, it is only natural that religion especially Christianity plays the central role in Korean immigrants' adaptation. Korean immigrants are well known for their intensive participation in ethnic religious organizations. According to some estimates, close to 70 percent of Korean immigrants are affiliated with ethnic churches. By 2003, there were over 250 Protestant churches covering twenty-four denominations, four Roman Catholic congregations, and five Buddhist temples in the Chicago area. A few churches out of this large number were selected due to significance related to their organizations.

Besides congregations, there are seven ethnic seminaries, over thirty mission organizations including TV, radio stations, and newspapers. Considering the fact that only one ethnic church existed until 1964, it is literally an exponential growth. Examples of church related organizations are Korean Ministers' Conference in Chicago, Korean Churches Federation of Greater Chicago, Korean World Mission Council for Christ in Chicago, and International Gospel Mission of the U.S.A. They organize a Hallelujah evangelical rally each year and Korean World Mission convention once every four years. Another noteworthy phenomenon is the growth of the Korean young adult congregations in recent years.

A procession of Korean Missionaries from around the world is seen here at the Fourth Korean World Mission Conference, 2000. (Courtesy of Rev. Peter Young Kil Kim.)

Hanmee Presbyterian Church, organized in 1964. (Courtesy of Hanmee Presbyterian Church.)

Alliance Holiness Church, organized in 1971. (Courtesy of Rev. Peter Young Kil Kim.)

Korean Martyr's Catholic Church, organized in 1970. (Courtesy of Rev. Peter Young Kil Kim.)

Asbury Korean United Methodist Church was the first church in the western suburbs. The church's original name was Korean First UMC.

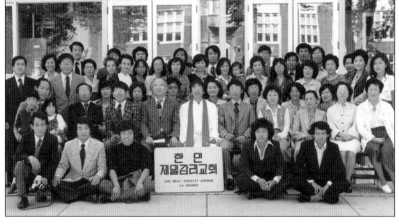

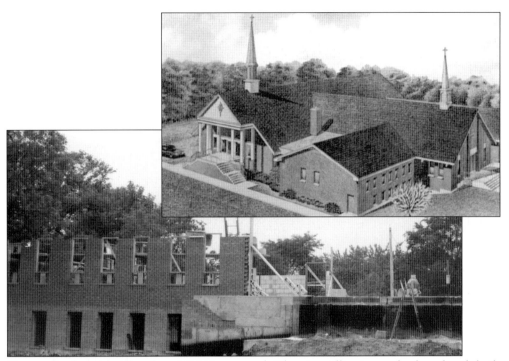

Canaan Presbyterian Church at 1424 Greenwood, Glenview, Illinois was the first church built by Korean Americans as opposed to being purchasing from another American congregation. The photo on the left shows the church under construction and the right photo shows the main church complex after the completion of the construction in May 1982. (Courtesy of Canaan Presbyterian Church.)

Rev. Yong Sam Rhee, the principal minister of the Canaan Presbyterian Church, displays a bag for shipping flour to North Korea to be used in Sariwon Noodle factory, which was built by Canaan Church in 1989 in North Korea to help prevent starvation. (Courtesy of the *Korea Daily*.)

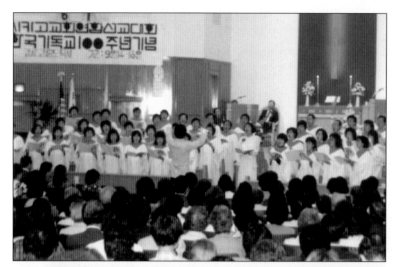

This Mission Rally was organized by Korean Churches Federation to commemorate the centennial of Christianity in Korea in November 2002. (Courtesy of Rev. Peter Young Kil Kim.)

Sunday worship at Lakeview English Congregation in 2001. (Courtesy of Lakeview Presbyterian Church.)

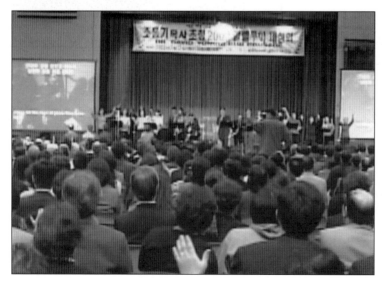

Rev. Dr. David Yonggi Cho preaches in March 2002 at the "2002 Hallelujah Evangelical Rally." (Courtesy of Full Gospel Chicago Church.)

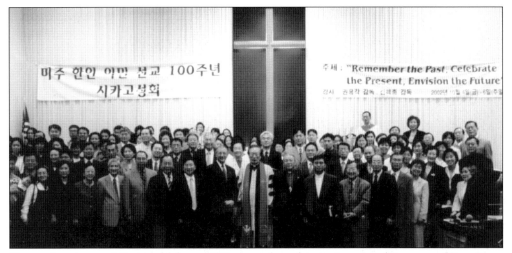

Korean Immigrants Mission celebrates 100 years of worship in America. (Courtesy of Rev. Peter Young Kil Kim.)

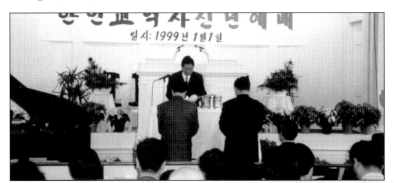

New Year's Day communion and worship of ministers. (Courtesy of Rev. Peter Young Kil Kim.)

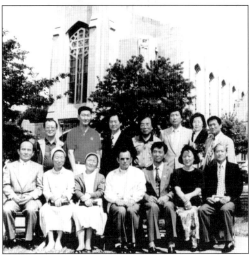

The members of the Queen of the Angel Catholic Church pose at their old church before leaving to go to their new church in July 1994. (Courtesy of Dae Hee Kang.)

Cardinal Stephen Kim from Korea celebrates Confirmation Mass with 42 Koreans. (Courtesy of Dae Hee Kang.)

Jin Chul Senim, a senior monk in Korea, preaches at Bultasa. (Courtesy of Bultasa.)

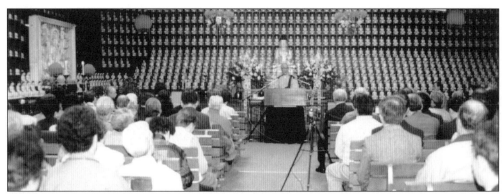

Bultasa Buddhist Temple in Chicago. (Courtesy of Bultasa.)

A hall of worship at the Bultasa Temple. (Courtesy of Bultasa.)

Eight
MEDIA, ARTS, AND ENTERTAINMENT

The Korean-American community has a large number of media outlets in the Chicago area. There are two daily newspapers, several weekly newspapers, two radio stations, and two TV stations. The media outlets provide wide-ranging coverage of the activities and programs taking place in the Korean community. The media also perform a valuable service to the community by keeping them well informed of news from Korea.

Arts and culture also play an important role in Korean-American society. While there are many artists sent to Chicago by the Korean government, there are also many second-generation artists from the area. Throughout the year, there are many artists and popular entertainment performances being carried out in the Korean-American community.

This traditional Korean fan dance was performed by Korean-American students of the University of Chicago at a Korea Culture Show in 1998. This dance is one of the most beautiful and appealing folk dances of Korea. The grace of the music, combined with the colorful costumes of the dancers and the shifting geometrical designs created with the fans accounts for the popularity of this dance.

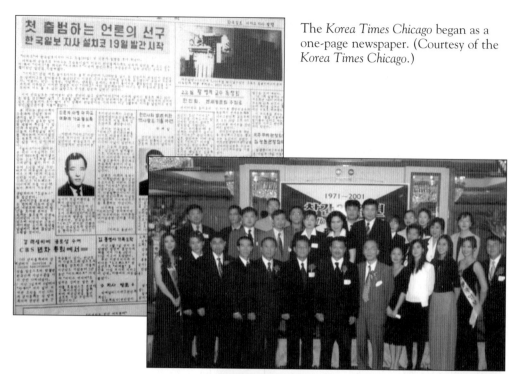

The *Korea Times Chicago* began as a one-page newspaper. (Courtesy of the *Korea Times Chicago*.)

Above, right: The 30th anniversary of the *Korea Times Chicago*. (Courtesy of the *Korea Times Chicago*.)

The *Korea Daily's* new headquarters building was occupied in September, 2000. (Courtesy of the *Korea Daily*.)

The *Korea Daily* staff took this last picture in front of their second headquarters building before moving to their new location in Elk Grove to face a new era of challenges and expended business in September, 2000. It was established in 1979. Their first headquarters was located on Irving Park Avenue in Chicago. (Courtesy of the *Korea Daily*.)

Kyung Lah, CBS 2 reporter, was born in Seoul, Korea, grew up in Streamwood, Illinois, and graduated from the University of Illinois with highest honors. (Courtesy of Kyung Lah.)

Right: KBC TV, Channel 28, Korean-American owned TV station. (Courtesy of Channel 28.)

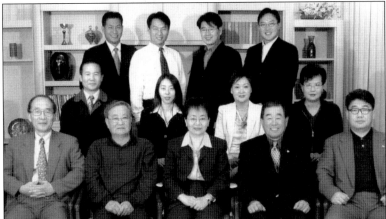

Left: Weekly news magazine *Weekly Seoul*. (Courtesy of *Weekly Seoul*.)

Right: The Korean News of Chicago.

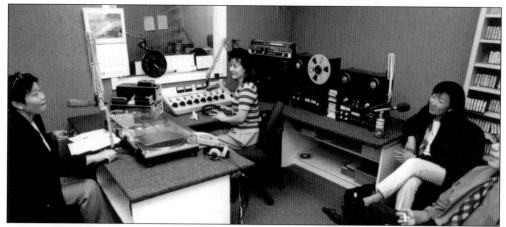

Chicago Korean Broadcasting Inc., a radio station, is found at AM 1330. (Courtesy of CKBS.)

Some of the supporters of Korean Christian Broadcasting, AM 1590. (Courtesy of Korean Christian Broadcasting.)

Anchorwoman Sun M. Choi with co-workers on "Total Living with Jerry Rose." Two-time Emmy award nominee Sun M. Choi is the executive producer and creator of "The Newsmakers," aired on TLN Cable TV. (Courtesy of Sun Mi Choi.)

Kyu Young Park, vice president of KAAC, is seen here being interviewed by an NBC news team regarding the Korean community's reaction to Dong Sung Kim, a Korean speed skater, loosing the gold medal in the Winter Olympic in 2001 in Salt Lake City to Apolo Anton Ohno, the Japanese American ice skater due to the unfair ruling of the judges. (Courtesy of KAAC.)

In the 1960s and 1970s, the Kim Sisters became an American household name thanks to the Ed Sullivan Show. The Korean-born singers, drummers, and dancers made over 200 appearances on the legendary weekly TV variety show. This scene is from their regular performance at the Palmer House's Empire Room. (Courtesy of K.C. Lee.)

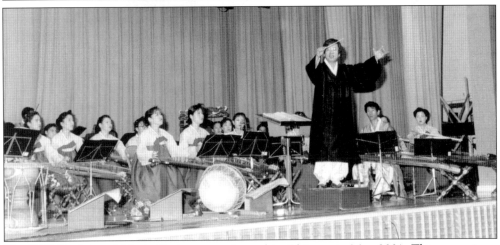

The KBS Traditional Music Orchestra performed in Chicago in May 2001. This group is an affiliated orchestra to the Korean Broadcasting System and was founded in 1985. (Courtesy of Chong Sik Kim.)

SamulNori's (percussion ensemble) music is based on the rhythms of traditional Korean folk percussion music. The name SamulNori literally means "the play of four things." The four things refer to the four percussive instruments: Kkwaenggwari (small gong), Jing (large gong), Janggo (hourglass drum), and Buk (barrel drum). (Courtesy of Chang Yoong Lee.)

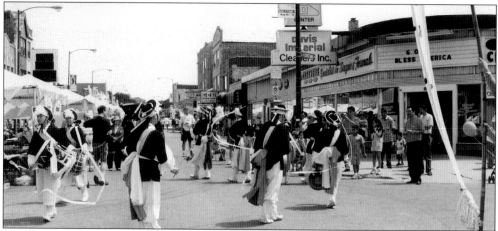

The Farmer's Dance team is seen here performing at the 6th Bryn Mawr Korean Street Festival in 2001.

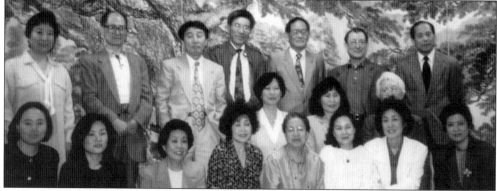

Korean Calligraphy Club, "Muk Mi Whoe," students pose with their teacher, Kun Suh Park, a well-known calligrapher. (Courtesy of Mi Soon Bae.)

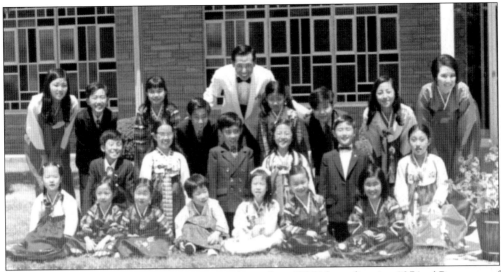

Korean Children's Choir of Chicago performed in WGN studios in 1971. (Courtesy of Chang Yoong Lee.)

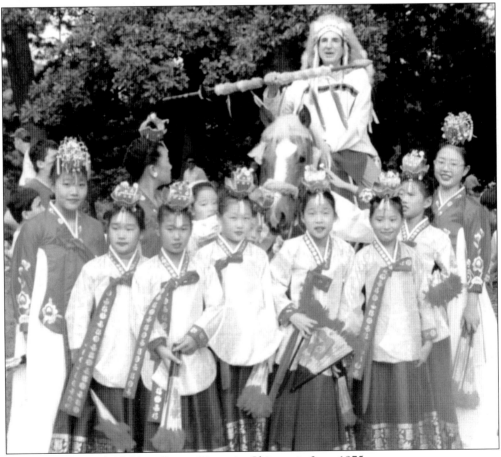

Korean Traditional Children Dance Troop in Chicago in June 1975.

Northeastern Illinois University (NEIU) invited world renowned, Korea-born soprano Sumi Jo for its millennium festivities in January 2001, celebrating the inauguration of its new Recital Hall in the Student Union building. Sumi Jo is praised for the remarkable agility, precision, and warmth of her coloratura voice and for her outstanding musicianship. (Photograph by Joe Davis.)

FAULKNER COMPETITION, 2000: THE WINNERS

Best Short Story, 2000:

YANGBAN
by Junse Kim

The gold medal for Best Short Story, 2000 is presented to Junse Kim of San Francisco, CA for *Yangban* by The Collins C. Diboll Private Foundation in memory of the late Mr. Diboll, a noted philanthropist in the arts and education. A graduate of the University of Illinois with an MFA from Goddard College, Kim has taught with Youth Speaks in San Francisco, leading writing workshops for young people at risk. He has served as membership director for a global non-profit devoted to human rights, served in Tunisia in the Peace Corps, worked as an editorial assistant for an English magazine publisher, and written non-fiction for consulting firms. Currently, he is working on a novel and a story collection.

THE JUDGE: TOM F

The judge, Tom Franklin, winner of both The
his collection, Poachers, had this to say about the w

A polished, masterful story, which grows richer with each re

At the 2000 Faulkner Competition, the best short story was awarded to "Yanban" by Junse Kim. (Courtesy of Chung sue Yoon.)

Junny Yune has appeared on many television programs, including "Johnny Carson's Tonight Show." He also starred in a comedy movie, *They Call Me Bruce*. Starting in 1970, he came to Chicago every year for ten consecutive years, to raise funds in the Johnny Yune Open Golf Tournament for various social service organizations in Chicago at great personal expense. However, in 1987 he came to Chicago to raise funds for the 1988 Seoul Olympic Games. (Courtesy of Chong Sik Kim.)

120

Nine
SPORTS

In Korean American life, sports have always played an important role. Most of the sports that are played in Korea have been taken up and played in the United States. Among the various sports enjoyed by Korean Americans are soccer, golf, Taekwondo, wrestling, and even kite flying. In addition, the American community has also enjoyed the opportunity of seeing Korean players in professional baseball and golf in U.S. cities.

In 2002, Korean Americans living in the Chicago area had the delight of seeing the Korean national soccer team go all the way to the finals in the 2002 World Cup match that was jointly hosted by Korea and Japan. Some Chicagoans even went to Korea to watch and cheer for the Korean team, others gathered at the Korean American Association of Chicago or other places where a giant screen was available to watch and cheer the games together.

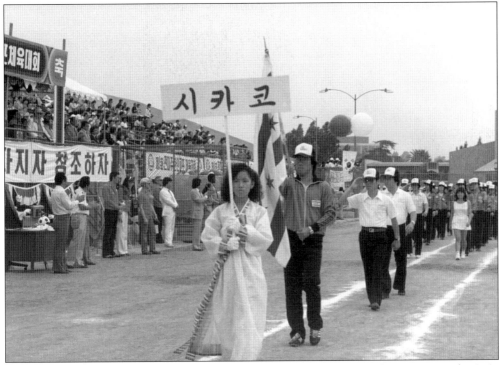

The delegation from the Korean American Athletic Association of Chicago enters the L.A. Stadium for the first bi-annual sports competition among Korean Americans from all over the U.S. in 1980. (Photograph by Chong Sik Kim.)

Above: Tennis match between students of Northwestern and University of Chicago, 1952. (Courtesy of Korean Table Tennis Association.)

Left: In 1985, the Olympic torch was carried by Kee-Chung Shon in Chicago who took the gold in the men's marathon at the 1936 Berlin Olympics. (Courtesy of Chang Yoong Lee.)

Kyung S. Kwack, the first president of the Choong Chung Do Community Association of Chicago, presents a championship trophy to Song Yul Kim at the 1979 Serum wrestling match. The champion later became a Physical Education professor at Dong Ah University in Pusan, Korea. (Courtesy of Kyung Sik Kwack.)

The Grand Kite Festival for Peace was held on the lake shore at Montrose Beach on August 11, 2000 as a Millennium Cultural Event wishing "Peace on Earth and Peaceful Unification of South and North Korea." Two thousand Korean "winged" kites were flown over the Montrose Harbor by Professor Sunwoo Lee from Dongeu University in Pusan, Korea and his members of the Nareyun Team. (Courtesy of KAAC.)

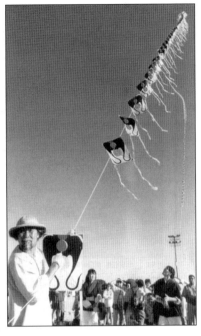

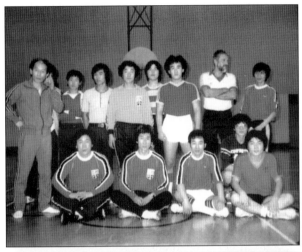

Korean Community Football Team, Hallelujah Football. (Courtesy of Ji Yong Lee.)

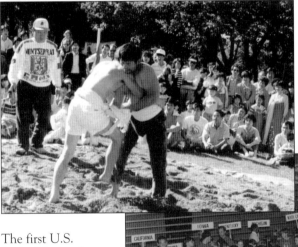

At Korea Day in 1992 we see the Sireum (Korean-style wrestling) Competition, which took place at Lake Michigan's Peterson Park during Chusuk (Korean Thanksgiving Holiday) in 1989. (Courtesy of Chung Sik kim.)

The first U.S. Junior National Taekwondo Championship Opening Ceremony. (Courtesy of Midwest Taekwondo Association.)

The 2002 FIFA World Cup was held from May 31 to June 30 in Korea and Japan with the participation of 32 teams. As Korea scored victory after victory, enthusiastic Korean-American soccer fans in the Chicago metropolitan area came to the Korean Association of Chicago meeting room to watch and cheer the games together. (Photograph by Young Sik Cho.)

World Cup in Seoul. (Courtesy of KAAC.)

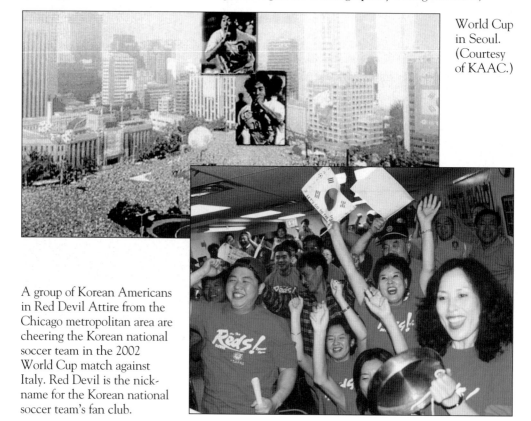

A group of Korean Americans in Red Devil Attire from the Chicago metropolitan area are cheering the Korean national soccer team in the 2002 World Cup match against Italy. Red Devil is the nickname for the Korean national soccer team's fan club.

Pro-golfer Se-Ri Pak was the first Korean to win both the U.S. Open at Wolf Run in Wisconsin and the LPGA Mc Donald's Championship Game, which she won on May 17, 1998. (Courtesy of Midwest Korean Golf Association.)

Below: The first Korean major league baseball player is first baseman Hee Seop Choi, who plays for the Chicago Cubs and won the National League Rookie of the Month of April title. He is the first Korean-born position player in the Major Leagues. (Courtesy of the *Korea Times Chicago*.)

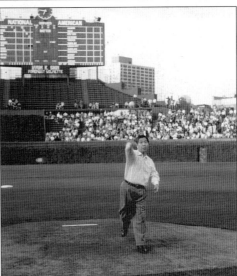

Here, Chan Ho Park, a former pitcher of the L.A. Dodgers visits Chicago and plays against the Chicago Cubs in 1993. Chan Ho Park was the first Korean pitcher to play in a Major League baseball game. (Courtesy of the *Korea Daily*.)

Hyun Koo Shin, president of the Korean Liquor Merchant's Association throws out a game ball at Wrigley Field for a game between the Chicago Cubs and Milwaukee Brewers on June 15, 1998. (Courtesy of Hyun Koo Shin.)

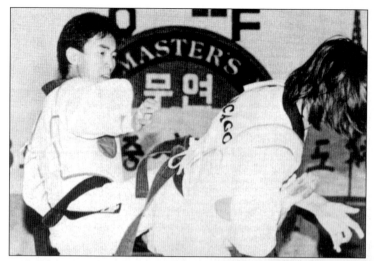

During this Taekwondo match at Korea Day in 1992, Master Tae Woong Kim and Eun Shin demonstrated self defense skills and how to develop and discipline both the body and the mind. (Courtesy of Midwest Taekwondo Association.)

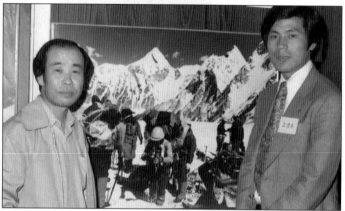

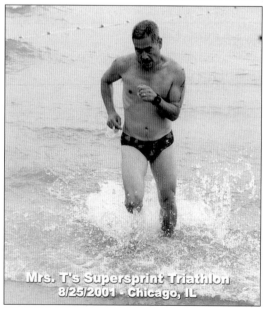

Above: Sang Don Koh, the first Korean to climb Mt. Everest visited Chicago. He posed with the sponsor of the photo exhibition of his historic climb, Kyung S. Kwack, vice-chairman of the board of the Chicago Korean-American Chamber of Commerce in 1977. (Courtesy of Kyung Sik Kwack.)

Left: Zero Shim is shown participating in the Supersprint Triathlon in August 2001. (Courtesy of Zero Shim.)

Yong Kil Kim, a former president of the National Korean American Sports Association welcomes sportsmen from all over the U.S. to Washington D.C. in 1996. (Courtesy of Korean American Athlete Association.)

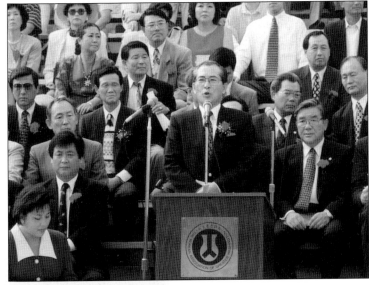

The Jubilee Cross-Continental Bicycle Team arrives and peddles down Lawrence Avenue in Chicago on their way to New York. In celebration of the 50th anniversary of Korea's Independence from Japanese rule, the six-member team (between the age of 13 and 78) left Los Angeles on June 25 and arrived at the United Nations Center in New York, their final destination, on August 15, 1995 traveling 4,800 miles. (Courtesy of the Korea Daily.)

The Chicago Korean-American sports team arrives at Washington National Airport in 1996. The team represents various sports including basketball, volleyball, swimming, soccer, golf, Tae Kwon Do, and tennis. (Courtesy of the Korea Daily.)

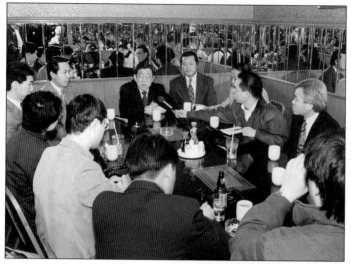

Woon Yong Kim, a former candidate for the presidency of the International Olympic Committee and a key advocate for the inclusion of Taekwondo in the Summer Olympics visited Chicago in 1993. This picture shows Mr. Kim being interviewed by members of the Korean-American Press with Duk Gun Kwon, 22nd president of the KAAC. (Courtesy of Chong Sik Kim.)

The Korean-American Alpine Club of Chicago was established in 2001 to promote mountain climbing in the Korean community. The photo on the left shows Zero Shim, the president of the Korean Alpine Club of Chicago and his wife (on the right) posing among the group on top of Mt. Elbert in Colorado. (Courtesy of Korean American Alpine Club.)

The planning committee for the KAAC's Open Golf Tournament at Chapel Hill Club posed after the event in 2002. This annual event was held to raise funds for KAAC's activities. (Photograph by Young Sik Cho.)